CLIP ART SMART

CHOOSE AND USE

THE BEST DIGITAL

CLIP ART

CLIP ART SMART

CHOOSE AND USE
THE BEST DIGITAL
CLIP ART

MOLLY W. JOSS

Rockport Publishers
Gloucester, Massachusetts

First published in the United States of America by:
Rockport Publishers, Inc.
33 Commercial Street
Gloucester, Massachusetts 01930
Telephone: (508) 282-9590
Fax: (508) 283-2742

Distributed to the book trade and art trade in the United States by:
North Light Books, an imprint of
F & W Publications
1507 Dana Avenue
Cincinnati, Ohio 45207
Telephone: (800) 289-0963

Other distribution by:
Rockport Publishers, Inc.
Gloucester, Massachusetts 01930-1299

ISBN 1-56496-294-6

10 9 8 7 6 5 4 3 2 1

Designer: CopperLeaf Design Studio, Columbus, Ohio

Cover/Jacket images: From T/Maker's Art Parts, Creative Fuel, and Bundle Up for the Holidays collections, as well as Classic PIO Partners and Cartesia.

Printed in Hong Kong.

CONTENTS

PREFACE

Clip art is one of the graphic artist's quiet essentials. Without it, printed matter (and our world) would be a lot plainer. There simply aren't enough good artists around to create original drawings. Without clip art, we'd have to make do without a lot of the art we see. Either that or we'd all learn to draw before we learn to read! Since my drawing skills have never progressed much beyond the level of simple stick figures, I'm one graphic artist who is profoundly grateful that digital clip art exists.

So why a book about clip art? A few years ago, while writing an article on clip art for a desktop publishing magazine, I was struck by the number of wonderful collections of digital clip art that could be had for very reasonable prices. Literally stacks and stacks of CD-ROM disks existed—each full of interesting, complex, and completely usable art. Someone had to tell graphic artists and designers about these treasures, and I decided it should be me. The folks at Rockport agreed (thank goodness), and that's how *Clip Art Smart* came to be.

This book is written with the needs of the graphic artist and visual designer in mind. Not only does it contain examples of some of the best digital clip art available today, but it also includes technical information and design tips. Some of this information can be applied to any type of graphic, not just clip art, but if it helps you get the most out of your clip art money, I included it.

What's more, the companion CD-ROM has hundreds of royalty-free clip art images, as well as software demos and shareware programs. Some of the images you see in the book are on the CD-ROM, plus scores of others.

Some of the information in this book comes from my own years of experience in the graphic arts industry. Some comes from interviews and discussions with industry folks and other designers. Some of the technical information comes from the technical databases and published papers of companies in the publishing, printing, and graphic arts industries.

I would like to thank the great folks at Rockport for their help and support, especially Don Fluckinger, my editor. Don patiently listened to my many ideas for the book, helped me get the job done, and held my hand when things got rough.

I am happy that this book could include examples of what professional artists can do with clip art. My thanks to the graphic artists who contributed their time and artistic efforts. Thanks, too, to the clip art companies and software vendors who supplied illustrative materials, clip art galore for the book and CD-ROM, and software for the CD-ROM.

Enjoy!

Molly W. Joss

INTRODUCTION

CLIP ART: WHAT IT'S ALL ABOUT

Most people think of clip art only as the simple black-and-white line art used in newspaper advertisements. But that's not the whole story. The magic of computers has made it possible for companies and individuals to create and sell large collections of complex, ready-to-use digital images that can be imported into desktop-published documents.

There are many different kinds of clip art, including object photography, color line art, cartoons, maps, borders, symbols, and icons (this book will cover each of these kinds in upcoming chapters). Collections of clip art exist in so many different subject categories: astrological, business, food, medical, military, religious, and even zoological. If you can think of something that a lot of people care about, chances are there's a collection of clip art images related to the topic.

Thousands of clip art images are available on every imaginable topic. There's black-and-white clip art, color clip art, and even photographic clip art images.

A PICTURE IS WORTH
A THOUSAND BYTES

Remember that old saying, a picture is worth a thousand words? Well, for the graphic artist, a well-chosen piece of clip art can be worth a thousand hours of time or even a thousand dollars. As a graphic artist or designer, you make a living (or at least some money) turning ideas and concepts into expressions. Nothing helps that process along faster than including a few images.

An exaggeration? Maybe if you're talking about one project. But what if you had to draw every image you used? Could you be as productive as you are now?

If you're like me, your lack of drawing skills could have kept you from getting into the business to begin with. Imagine what it would be like if you had to build a car before you could drive or build your own computer before you could create a design.

For years, clip art was considered cheap, mostly unusable, and even kind of cheating by professional graphic artists. To be sure, the clip art available to the general public wasn't (and some still isn't) the best quality. The best nondigital clip art was created by image bureaus, companies that specialized in creating line art that could be "clipped" from sheets and literally pasted onto pages of type. This artwork was available only to those designers who could afford to pay for the reproduction rights.

When companies first started converting their print clip art collections into digital formats, much of the existing art was scanned to create bitmapped images. Used at the wrong size or resolution, these images looked terrible and could hurt a design more than they helped. Thanks to the introduction of computer drawing programs and the work of many computer illustrators, clip art is more detailed and professional-looking than ever. Much of it is useful as it is, right off the disk.

You wouldn't know this is clip art unless someone told you. It really is, we swear!

Clip art is sometimes bundled with page-layout programs or other desktop publishing applications. Some of this clip art is great, so don't sneer at it because it's free. But in general it won't be the best available, and since it's bundled, it'll turn up more often in other people's designs than you may like. Still, with a few changes you can make it look brand-new. The clip art that comes bundled with software can be a valuable resource. Don't overlook it.

Simple clip art that looks like this comes free with desktop publishing applications. Though its use may be limited in scope, don't discard it.

Today there's so much clip art available that it's difficult for a graphic artist to decide which collection to buy. With a little bit of experience and knowledge of what questions to ask (which you'll get from reading this book), making those decisions will be easier. You'll also know more about how to get the most out of the clip art you have.

You can buy clip art packages in large computer stores and through mail-order catalogs. The clip art packages in computer stores tend to be large general collections—you

know, 20,000 images for $19.95. Even this kind of clip art collection can be useful to a graphic artist. It's inexpensive and usually has some usable art in it!

Through mail-order catalogs that cater to the graphic arts, you'll find the more upscale, specialized clip art collections. If you want a collection of clip art for a specific application or type of design work, check catalogs first. Even if you don't see the exact collection you want listed, call some of these companies and ask if they have something they haven't advertised.

Catalogs are also good sources for the more expensive and more sophisticated clip art collections, especially object photography images. You may pay hundreds of dollars for a collection with fewer than a thousand images in it, but even at this price it only takes a few projects to pay for the whole collection.

Look in graphic arts catalogs for specialized clip art collections, such as this collection of clip art maps from Digital Wisdom.

You can also collect clip art at trade shows, on bulletin boards, at Web sites, and in on-line forums. Other sources of information about collections are printed and online software directories.

CLIP ART: WHAT CAN YOU DO WITH IT?

You can use clip art just as you would any illustration or image: to convey a stand-alone concept or to support the surrounding text.

You can even create an entirely new design from a handful of clip art images.

Icons, cartoons, and symbols are great for conveying a single concept.

An entirely new design can be created from existing clip art.

An appropriate image can be used to support and amplify the meaning of text.

CLIP ART: MAKING THE MOST OF IT

Try to use clip art just as you find it. At least, that's the first thing to look for when choosing clip art—the more work you have to put into it to make it usable, the higher the "cost" of the image. But don't overlook the clip art image that will work with just a little bit of effort. Perhaps eliminating some elements or changing some colors will increase its usefulness. Use the how-to tips and examples in this book to help you make the right choices.

USEFUL CLIP ART TOOLS

Clip art collections alone aren't enough to get the job done. You need software tools such as viewers, file translators, image-editing programs, and image databases. Without these valuable tools, you can't do much more than import as-is images into your page-layout program. With them, you can leverage your investment and make the most of what you've got.

You also need solid technical information about the digital side of digital clip art. This book provides everything you never knew

Good clip art can be used just as it is. Try to find clip art that will work with no changes or with just a few minor ones.

you needed to know about file formats, file compression methods, cross-platform issues, and a host of other matters.

Manufacturing

Software utilities and technical know-how are two important underpinnings for the successful long-term use of these great images.

COPYRIGHT ISSUES

It has nothing to do with talent and nothing to do with technical expertise—yet it's something graphic artists have to know. I'm talking about the copyrights attached to your images. You have to know the basics of how copyright law works in your country, and you have to know how to register a copyright and how to defend it. It's one of the best ways to protect the investment you put into your work.

With clip art, copyright issues are particularly touchy. This artwork is someone else's work to begin with, so there are legal rights attached to the work before you use it. But it's intended to be used; it's being sold so you can use and re-use it.

Protect your investment by knowing about copyrights.

Clip art is an extraordinary resource for every graphic artist. You can use it in ways you never thought of before. Explore your world through clip art.

Let clip art feed your imagination.

You must know the differences between the terms "royalty-free" and "copyright-free." There is a difference, and knowing it can make the difference between happy customers and angry ones, and between losing your shirt in court and keeping it.

While nothing other than solid legal advice will answer every question, you'll find detailed information about copyrights as they relate to graphic arts in general in this book, and you'll also find thought-provoking information about copyrights and clip art.

LET YOUR BRAIN LOOSE

Whenever you look at a piece of clip art, whether you're trying to decide to buy it, use it, or change it, use your imagination. Squint a little, scratch your head whatever it takes to let your brain loose to explore what's possible. The information and examples in this book will help. Try some of the tips and tricks on the clip art on the companion CD-ROM.

MAKING IT HAPPEN: TECHNICAL HOW-TOS

To get the best out of digital clip art, graphic artists have to acquire a new skill set that has nothing to do with graphic arts and design. They need strong computer skills.

It would be great if all artists and designers had to do with clip art was drop it into the documents they create using their word processing or page-layout programs. Unfortunately, it's not that simple. There's a lot to know about the technical side of clip

art. Fortunately, there's nothing about the technical side of clip art that is beyond the comprehension of any graphic artist.

The nuts and bolts behind clip art aren't as much fun to read about as learning how to make great pictures with clip art. However, this is basic information every graphic artist needs to know.

Some of the information in this chapter will help when you're deciding what kinds of clip art to buy. Some will help you make the most of design time. In any case, being technically astute about clip art helps at every stage of the game.

Graphic artists need to know the difference between a bitmap graphic and a vector graphic, and they need to know which of these two basic file formats to use and when. Some files are better than others for some

design applications, so they need to know about converting files from one format to another.

Since the design world is not exclusively Macintosh-based, they need to know how to exchange files between PCs and Macs. As a related matter, it's good to know when and how to compress graphic files.

QUICK TIP

WHAT TO BUY?

Find out exactly which graphic file formats your word-processing, page-layout, and image-editing software can import and edit before investing in a lot of clip art.

Only buy clip art your image-editing software can import and edit—or buy software that can import and edit the clip art you want to use.

EVERYTHING YOU ALWAYS WANTED TO KNOW ABOUT FILE FORMATS BUT DIDN'T KNOW WHO TO ASK

Think of a file format as the outside packaging and internal structure of a graphic, something like an envelope that contains a set of digital information. The "envelope" tells the computer how to interpret the information it's

receiving. The "contents" inside the envelope are the data.

Over the years programmers and software manufacturers have created a variety of file formats. Some are text file formats and some are graphic file formats. When you save a file in any application, you are saving it in some format. While working on a design, choose the application's native file format. This procedure works well as long as you don't need to use that file in another application.

When working with text, ASCII is the most common file format. Files saved in this format lose all of their text style formatting, but other programs are more likely to be able to open them.

For graphic files, software manufacturers have created dozens of file formats. TIFF (Tagged Image File Format) and EPS (Encapsulated PostScript) are two formats most paint, draw, page-layout, and word-processing programs can import.

To import the file with another application, you need to save the file in a format the other application can recognize—a standard envelope.

It's a good thing there are standard file formats; otherwise computers wouldn't be able to exchange data files.

TWO BASIC KINDS

Although each file format is different, there are two basic kinds of graphic file formats: bitmapped (also known as raster) and vector (also known as object-oriented). Both kinds offer advantages and disadvantages. It's a good idea to know about the differences between the two basic file formats and how those differences affect your design work.

Spending any time with image-editing programs highlights one of the graphic facts of life very quickly: Sometimes you can import an image but you can't edit it. This is one of the most confusing and frustrating aspects of graphic arts design. And it always seems to happen at deadline time.

Here's the secret. Bitmap graphics can only be edited in paint or bitmap editing programs, and vector graphics can only be edited in draw or object-oriented editing programs.

For example, a TIFF file can easily be edited with Photoshop, but it must be converted to an EPS file (or some other vector format) to edit it in Macromedia FreeHand, which has an auto-trace function.

BITMAP GRAPHICS

Bitmap graphics can be useful for graphic artists, although they have some limitations when it comes to using them for documents printed at higher resolutions. These kinds of files tend to be less expensive than vector graphic clip art. Bitmap graphics can also be imported into many different word-processing and page-layout programs.

In bitmap black-and-white clip art, image elements are composed of black dots. In grayscale images, each dot can be black, a shade of gray, or white. When black-and-white photographs are scanned, they become grayscale images.

COMMON BITMAP FILE FORMATS

BMP—Microsoft developed this file format for Windows graphic files.

MSP—Microsoft developed this file format for Microsoft Paint.

PCX—ZSoft developed this file format for Publisher's Paintbrush. It is one of the most widely supported bitmap graphic file formats.

PICT—Lotus created this file format for graphics used in Lotus 1-2-3, a popular spreadsheet program.

PNT—Claris developed this format for the paint program MacPaint.

TIFF (Tagged Image File Format)—This is a rare example of a file format created by a group of companies that worked together to establish a standard format.

Strictly speaking, a bitmap graphic file is nothing more than a collection of pixels (dots) that form an image.

Bitmap graphics are limited to the resolution they were created at. Enlarging the image usually makes it look worse rather than better.

Enlarging a bitmap a small amount usually isn't noticeable. If enlarged less than 10 percent, the image degradation is negligible. Unless it is a high-quality bitmap created at a high resolution, enlarging it more than 10 percent makes the image look jagged. These undesirable effects are especially apparent when the image is printed at resolutions of 600 dpi or higher.

Because bitmap images look jagged when enlarged, avoid enlarging bitmap graphics.

Reduce a bitmap graphic from its original size, and it won't appear jagged. Reducing it won't improve the resolution, though.

It isn't always easy to use bitmap clip art at the same size it was created. After all, you didn't create it, so you have no way of knowing what size the original image was when you're looking at a thumbnail in a catalog or viewer. When in doubt, investigate a little before buying. Call the company that publishes the clip art collection before purchasing. Ask them what file formats are available.

If only bitmap images are available, ask what resolution the images were created at and how large they are. Ask if the company sells a sample disk so you can try a few images before you invest in the entire collection.

Another way to check out clip art before you buy it is to download files from the company's Web page; sometimes companies put samples there.

Bitmapped images can work well for designs that will only be seen on a computer monitor, including multimedia and Web designs. Here the lower resolution of the files

doesn't matter since most monitors have display resolutions of less than 100 dpi.

In the illustration shown below, the simple piece of clip art is a TIFF file. When it's enlarged several hundred percent, you can see the individual dots that make up the image.

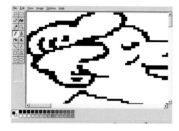

If you enlarge a bitmap image, you'll start to see the dots that make up the image.

It's simple to edit a bitmap file. Open the image in your favorite paint program and enlarge it so you can see the individual dots that make up the image. Then add or delete dots to edit the image. When you're finished making changes, reduce the image back down to its original size. Making extensive changes to an image one dot at a time can be time-consuming, so select images that don't require a lot of editing.

VECTOR GRAPHICS

The other basic file format is a vector (also known as object-oriented) file. The image data comprises shapes and coordinates instead of providing the dot-by-dot breakdown of the image.

If you look at the contents of a vector file with a text editor, you'll see a list of commands. These commands are from a page description language that tells the computer what to draw on the screen and tells the printer what to print.

COMMON VECTOR FILE FORMATS

AI—Adobe created this format for Illustrator files.

CDR—Corel developed this file format for Corel Draw files.

CGM (Computer Graphics Metafile)— A file format commonly supported by Windows drawing programs and other desktop publishing applications

DCS (Desktop Color Separation)—This is an extension of the EPS format developed by Quark.

EPS (Encapsulated PostScript Files)— Adobe created this very handy file format for its various applications.

PICT—No, you aren't imagining things. PICT was on the bitmap list, too. There are bitmap PICT files and vector PICT files.

PS—This file format was created by Aldus and is related to the EPS format. Designers often use the PS format to print a file without using the application that created it.

WMF (Windows MetaFile—Microsoft invented this format for exchanging graphic files in Windows programs via the Clipboard.

BITMAP OR VECTOR PICT FILES?

If you can't identify a PICT file as vector or bitmap, check the documentation for the program used to create the file to see what kind of PICT file that program creates. When in doubt, create a PICT file and try to edit it in FreeHand or another draw program. If you can edit it, it's a vector PICT file. Or, import the file into Illustrator. If there is an empty picture box on-screen, it's a bitmap PICT file.

FYI: Ofoto and Photoshop create bitmap PICT files. FreeHand, MacDraw Pro, and CorelDraw create vector PICT files.

Vector files are resolution-independent, which means they will adapt themselves to any resolution and still look the same. Use vector graphics for images containing type and for images that may be resized.

This absolute scalability makes vector files so versatile for the graphic artist. It removes the worry about how the files were created or what the optimum size should be. Vector graphics can be resized at will and mixed with other vector files without problems.

Vector files do have their limitations. The file sizes tend to be larger than bitmap graphics, unless you are working with scanned images. Scanned image files tend to be very large, especially when the image was scanned at a high resolution.

Vector graphic files are also more complex than bitmap files. After all, the computer or output device has to interpret the commands in the file, not just throw dots up on

the screen or on film. So, once in a while, vector graphic files won't import or image because the computer or printer can't interpret the file correctly. They can also create output problems if you use more than a few complex images in a single document.

```
Å_ÓÆ-_____
_____"_____
C__ÿÿ%!PS-Adobe-3.0 EPSF-
3.0
%%BoundingBox: -1 -1 116
135 %%Creator: Corel PHOTO-
PAINT
%%Title: %%CreationDate: Tue Oct
29 18:23:04 1996
%%DocumentProcessColors: Cyan
Magenta Yellow Black
%%DocumentSupplied
Resources: (attend)
%%EndComments %%BeginProlog
/AutoFlatness true def
/AutoSteps 0 def
/CMYKMarks false def
/UseLevel2 false def %Color profile: Disabled
%%BeginResource: procset wCorel6Dict 6.0 0
% Copyright (c)1992-96 Corel Corporation
% All rights reserved. v6.0 r1.1
/wCorel6Dict 300 dict def wCorel6Dict
begin/bd{bind def} bind def/ld{load def}
bd/xd{exch def} bd/_ null def/rp{{pop} repeat}
bd/@cp/closepath ld/@gs/gsave ld
/@gr/grestore ld/@np/newpath ld/Tl/translate
ld/$sv 0 def/@sv{/$sv save def} bd /@rs{$sv
restore} bd/spg/showpage ld/showpage{} bd cur-
rentscreen/@dsp xd/$dsp /@dsp def/$dsa
xd/$dsf xd/$sdf false def/$SDF false def/$Scra 0
def/SetScr
/setscreen ld/setscreen{pop pop pop} bd/@ss{2
index 0 eq{$dsf 3 1 roll 4 -1 roll
pop} if exch $Scra add exch load SetScr}
bd/SepMode_5 where{pop} {/SepMode_5 0
```

These are the opening lines of the EPS file for this map of California from Cartesia. Note the Bounding Box command, which gives the computer information about how to display the graphic on-screen. The file was created using Corel Photo-Paint, hence the mention of Corel in the file.

POSTSCRIPT FILES VERSUS EPS FILES

When you print a file to disk using a page-layout program, the software creates a PostScript file. This file contains everything a printer or imagesetter needs to know in order to output the file, so it's possible to image the file later without the application that created it.

Printing a PostScript file is easy. Use a file downloader utility to download it to a PostScript printer or imagesetter. Or import the file into a page-layout program and print it. If you import a PostScript file into a page-layout program, you will see nothing more than a blank box on the screen. The file should print, however.

Use an Encapsulated PostScript (EPS) file for individual graphic images. It contains all the PostScript coding needed to print the image, as well as the information the computer needs to display the image on-screen. When an EPS file is imported into a page-layout or image-editing program, an image of the graphic appears on-screen.

QUICK TIP

WORTH THE EXTRA COST

When in doubt as to what file format will work best, buy vector graphic clip art. It's more expensive than bitmap clip art, but it's more versatile. Its resolution independence makes it useful for printed pieces. Convert it to bitmap format to use it in a multimedia or Web design (as shown in chapter 6).

FILE CONVERSION TECHNIQUES

Vanilla is the most popular flavor of ice cream in America, but there are still lots of people who like chocolate and mocha fudge. So it is with computers in the graphic arts. The Macintosh is still very popular, but there are folks out there using other computers and other operating systems.

Moving files around from one type of computer to another isn't always the easiest thing to do, but there are some ways to make it easier.

QUICK TIP

MAC OR PC COMPUTER?

If you're not sure what kind of computer you're going to use the clip art with, try to buy a collection with Macintosh and PC format files on the same disk.

If the Macintosh and PC you want to share files with are on the same computer network, sharing files is easy. Simply copy the file onto the network's file server and then copy it to the computer on which you want to use it. If you're sharing files via floppy or removable, the procedure is a little more complicated. The first step is to make sure your computer can read "foreign" disks.

The second step is to make sure the file you're using is compatible with the kind of computer you have. Some graphic file formats, such as TIFF and EPS, can be imported by most Macintosh and Windows applications. Some, such as WMF, are platform-specific and must be translated before they can be used on a different kind of computer.

READING A PC DISK ON A MACINTOSH

The Macintosh PC Exchange utility is part of the System 7.5 (and higher) Macintosh operating system. PC Exchange lets you read DOS or Windows floppy disks, SCSI hard disks, and removable media on your Macintosh. You can also copy files to and from these disks.

The software won't translate or convert DOS and Windows files into Macintosh data files. It also doesn't include the magic needed to make PC applications work on your Macintosh. PC Exchange will not work on Macintoshes with only a double-sided, double-density disk drive, such as the Mac Plus, Mac SE, and II Series computers. It also will not allow you to read files that have been compressed with a DOS or Windows compression utility. The files must be noncompressed.

You can convert some Macintosh clip art or designs into a form a PC application can import. For example, MacDraw Pro files can be converted to ClarisImpact for Windows format. To do this, you need to have Convert2DOS, a conversion utility from Claris.

The folks at Apple Computer realized a few years ago that there are many flavors of computers and Apple users needed to share files with users of other systems. So they created some software to help Macintosh computers read DOS and Windows disks. Starting with System 7.5, they included PC Exchange.

You may be familiar with Apple File Exchange. It is an older utility shipped with all Macintoshes physically capable of reading a PC floppy, and it works with System 7.1.1 or earlier. File Exchange allows a Macintosh to read PC disks.

QUICK TIP

DUAL-PLATFORM WORKAROUND

Some DTP programs are dual-platform, meaning they're available in both Macintosh and Windows versions. If you import clip art into such a program and save the file in the program's native format (such as Photoshop format in Photoshop, rather than TIFF or EPS), you may be able to open the file in either version of the software. Check to see if you need to append an extension to the file name to open the file in the PC application.

If you are using System 7.1.2 or later and want to translate between file formats on the Macintosh, you have two basic options.

First, open the clip art file in an image-editing program. Then save it in another format. This approach works well for converting one bitmap format to another (say, PICT to TIFF) or one vector format to another (WMF to EPS).

Second, use a third-party translation utility. Use auto-trace programs like Adobe Streamline or Tracer to convert a bitmap file into a vector file. To convert a vector file to a bitmap, you can try opening it and saving it as a bitmap file in an object-oriented image-editing program.

READING A MACINTOSH DISK ON A PC

Unfortunately, the good folks at Microsoft have not built file translation and file-sharing utilities into their operating systems. You'll have to resort to third-party software solutions to read a Macintosh disk on a Windows PC.

You'll also have to resort to third-party applications to translate Macintosh files to DOS and Windows formats on a PC. Or, you can try the dual-platform workaround (see p. 21).

THE BIG SQUEEZE: FILE COMPRESSION

You don't have to know about how to compress and decompress a file to use clip art, but it helps.

IT HELPS WHEN:

- You download a graphic file from a Web site or the Internet and discover it's been compressed.
- You need to send some clip art to someone else via floppy or e-mail.
- You want to save an image in the right format to include it in a Web page.

To compress or decompress a file requires a file compression utility. Fortunately, there are many good ones, including some shareware programs available on the Internet.

All file compression programs work the same way. They examine a file and try to squeeze as much "air" as possible from the file. Every computer file has some "air" in it, although different compression algorithms define "air" differently.

When you compress a file, the computer squeezes the file to make it smaller.

Unless you're working with grayscale TIFF images, clip art files generally compress well. Complex vector graphics compress the best, as is shown in the illustration.

The comparatively simple rodeo clip art (supplied by Click Art) is a small file. The compressed files are much smaller than the original, no matter which kind of compression algorithm is used.

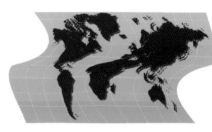

The more complicated world map clip art (supplied by Digital Wisdom) is a much more complex image. The EPS version of this file is much larger than the EPS version of the rodeo image. Although the vector file formats (EPS and WMF) are much larger than the bitmap versions (TIFF and BMP), all the file formats shrink considerably when compressed.

FILE SIZES: RODEO

File Type	Before	After
EPS	668 KB	22 KB
WMF	83.0 KB	7 KB
TIFF	78.3 KB	5 KB
BMP	78.2 KB	6 KB

FILE SIZES: WORLD MAP

File Type	Before	After
EPS	2.20 MB	1.01 MB
WMF	1.04 MB	643 KB
TIFF	638 KB	33 KB
BMP	638 KB	33 KB

BEFORE YOU BUY OR EDIT

1. There are two basic kinds of file formats used for graphics: bitmap and vector. Each has its own particular advantages and disadvantages.

2. Bitmaps don't look good when enlarged, so use them at the size at which they were created (or smaller). Vector graphics look good at any size.

3. A Macintosh can read a PC disk, thanks to capabilities built into the Macintosh operating system. It's also possible to translate one file format to another, although not all file formats work on Macintosh, Windows, and DOS PCs.

4. File compression isn't necessary to use clip art, although it's a good idea to know about the technology. It comes in handy when sending files to other people or decompressing files.

5. Most Macintosh monitors have a default display resolution of 72 dpi. Most PC monitors have a default display resolution of 96 dpi.

6. PC Exchange and Apple File Exchange are not compatible. Don't use them on the same Macintosh.

7. Buy vector-based clip art when possible. If only bitmap images are available, ask at what resolution the images were created and how large the images are. Ask the company for some sample images and try them before you invest in the entire collection.

8. Vector graphics can cause output problems if you use more than a few complex images in one document.

9. To compress or decompress a file, use a file compression utility. Fortunately, there are many good ones, including some shareware programs on the Internet.

10. Use an EPS clip art file instead of a PostScript file if you want to see what the image looks like before you import it.

Shareware file-compression programs such as IslandSoft EzZip are available on the Internet.

MAKING THE BEST OF IT: DESIGN TIPS

Some designers are reluctant to use clip art because they fear it will make their designs look canned. Something whispers to them that everyone else will be using the same images. It's not true. Get rid of that negative voice! Tell it to go whisper in someone else's ear. You don't have time to listen. With a few guidelines and precautions, you'll be able to use clip art for design just as easily and effectively as you choose type or other images.

Tell that negative thought to go away. You've got work to do.

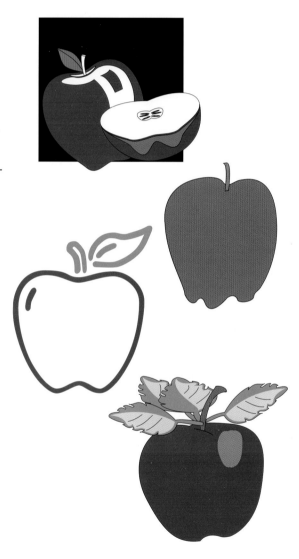

Even pictures of a simple object can convey different styles, moods and feelings—and look very different.

Some collections have very strong personalities; others are more mellow and laid-back.

You can use clip art as you find it on the disk without making any changes. All you have to do is import it into the document you're creating. The material in this chapter shows how to select images that are most suitable for a particular design "look."

You can also combine as-is images from a variety of sources in one document. Some care and thought must go into this approach, or you'll end up with a haphazard-looking design.

Finally, there are some quick and basic changes you can make to clip art to make it look very different from the original image, which should take care of the look-alike worries. In some cases, a few quick changes can make an image look totally different. The illustrations in this chapter show quick and easy ways to accomplish this.

If you spend time working with an original image using image-editing software, you can really individualize clip art. This approach takes time and may require several complex operations. These kinds of operations are covered in chapters 2 and 4.

CHOOSING CLIP ART IMAGES

To use clip art effectively, you'll have to spend some time getting to know your clip art collections. The best way to do this is when you have some time and you're not up against a deadline. What's that? People actually have time between deadlines? Yes, I know. No one has time just to sit around and look at clip art images. However, try keeping a stack of clip art CD-ROMs next to your computer. Pop one in the next time you're bored or you need some inspiration. You won't remember everything you see, but I guarantee some pieces will return to your mind as you're working on a project later on.

If you're browsing to help jump-start your imagination for a particular project, know what style, mood, and message you want to convey before you start looking for images. Because pieces of clip art are ready-made images, they can convey a considerable amount of visual content as you see them.

For example, you may know you want to include an apple in your design. As you can see from the apples shown on page 24, there are many different ways to picture even a simple object.

Over time, as you get to know your clip art collections, you will recognize styles in the different collections. Some clip art collections are created with a definite attitude in mind, while the art in other collections is more generic. Keep these different styles in mind. When your design calls for something with attitude, you'll know immediately which collection to use.

You'll also begin to associate clip art collections with clip art companies. So when a new collection comes out from your favorite clip art company, you'll already be familiar with the quality of the company's work.

As you're browsing, look for clip art that won't require a lot of changes. The fewer the changes you have to make, the more productive you can be. If you've thought about the overall design ahead of time, the right clip art will jump right out at you when you see it.

Here's another thought to keep in mind as you're browsing. Think about the other elements in the design, such as text and even white space. Your goal is a single integrated effect; no one image should dominate, unless the image is the message.

This brochure design was done with Little Men Studio clip art. Note the effective use of white space on the cover. The clip art is well integrated with the color and the text.

Strive for consistency of images throughout the design. The images don't have to look exactly the same, but they should look as though they coordinate. You want to use images that look like they belong together. One easy way to do this is to use images from a single collection.

You don't have to limit yourself to images from the same collection or even the same clip art company. As you browse through clip art collections, look for images that can be used together. Don't be afraid to mix and match. With some practice, you'll be able to spot compatible images easily.

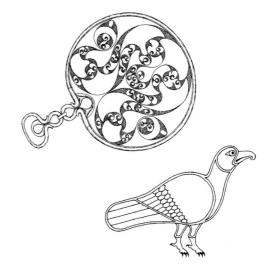

These images from the Highlander Graphics Celtic Collection look as though they go together.

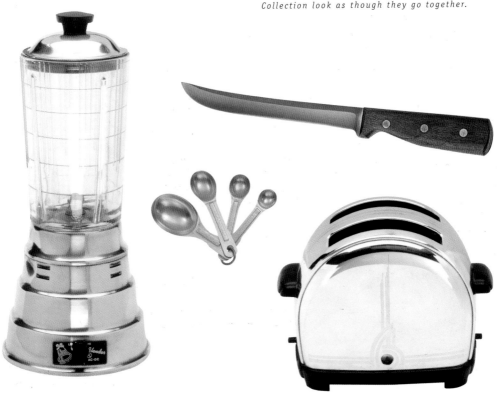

These four images are taken from two different object photography collections. Because they are all object photography, they are compatible images.

It's sometimes difficult to decide which image you should use in a design. That's normal. It's even good. So when you're looking for a piece of clip art, look at more than a few pieces. Look at different collections, and make sure to pick more than one image before you turn back to the design.

Add a blank page to the design at the end and import the images all at once. Try them one at a time in the design. This way you don't have to keep importing images; they're right at your digital fingertips. Just make sure to delete the extra page and unused clip art when you finish!

Unless your clients have made it clear that they want a specific image used in the design, chances are there are several different images you can use for a project. For example, you may not need to use an apple; it may be that any good-looking piece of fruit will do. So keep an eye out for related images.

Before you import clip art into a design, import the candidate images onto a blank page at the end of your document, and move them into the document from there. Re-import the image you choose at the end; Adobe advises not to cut-and-paste images.

TECHNICAL TIPS

To help speed up your browsing time, use an image viewer such as the commercially available Kudo Browser (which comes free with many clip art collections) to scout for likely looking images. With image viewers, you can scan through a group of images quickly. Stop when you see a likely looking one and enlarge the view to see the detail of the image. Write down the name of the disk and the name of the file you want to try.

Another way to look at images is to use the image importing commands in your page-layout or word-processing program. In most

Why use an apple when a cherry would do?

You can look at clip art one image at a time by using your software's image importing capabilities.

programs, you'll be able to see the images one at a time as you click on their names in the "Open," "Import," or "Place" dialog box. If you have the appropriate image graphic filters installed, you can see the images without actually importing them.

Once you find some images you'd like to experiment with, copy those files off the CD-ROM or floppy disk into a folder on your hard disk. You'll be able to keep better track of the images this way. If you decide to make any changes to the images, make them to a copy of the original file. Keep the copy you made intact in case you want to start over later.

Keep in mind file formats (see chapter 1) when selecting files. Sometimes the same images come in different file formats on the same disk. Know which file formats will work best for your project before selecting the clip art you'll use.

SHARPENING YOUR CLIP ART I.Q.

There are books of vocabulary words you can read to expand your repertoire of expressions. There are puzzle books to help you build your problem-solving mental muscles. But when it comes to expanding your clip art I.Q., you've got to do your own work. Here are some suggestions to help you increase your clip art creativity.

Experiment with clip art, even when you feel you don't have time. Feed your brain by browsing through clip art collections. Look for images that catch your eye immediately. Study each of these images. Decide what about it caught your eye. Was it the color or combination of colors? Was it the shape? Was it a new twist on an old idea?

When you do mental exercises such as these, you're not only getting to know your clip art, you're also sharpening your design instincts. You'll also be learning how to improve clip art images to make them better suit your purpose or to make them look distinctive.

Try applying special effects outlined in chapters 2 and 4 to other pieces of clip art. As you make these changes, keep notes. You could even create a journal of the changes you've experimented with. Include before and after printouts of your work with the notes. Make your own how-to book.

Keeping notes of the changes you've experimented with is a fun way to keep track of what you've done.

Play "Spot the Clip Art." Look at other people's designs to see if you can spot clip art elements, and see if you can figure out what changes they made. Use the same approach on entire designs that you use when browsing clip art. If a design catches your eye, study it to decide what about it makes it work. See if you can determine where the designer used clip art. You'll be surprised at how much you can spot once you've done this a few times.

Play "Spot the Clip Art." Once you get started, you'll be surprised how much clip art you see in use. This Web page was designed using clip art from Little Men Studio.

WHEN IT'S ALL SAID AND DONE

There, that wasn't so hard, was it? It's basically a matter of getting to know the strengths and weaknesses of the material (clip art) you have to work with. You do that by studying the images you have, by mixing and matching them in your mind and in your designs.

Working with clip art is fun. Build some creative time into your day and have fun with clip art.

© 1992,1994 CHARLES BARSOTTI

"It's his creative time."

BEFORE YOU BUY TIPS

1. Try to use clip art as you find it.

2. If you have to make changes, make as few as possible.

3. Copy the images you want to experiment with onto your hard disk.

4. Make your changes to a copy of the original of the file.

5. Keep in mind the appropriate file formats for your project.

6. Expand your mental and creative abilities by experimenting with clip art in between projects.

7. Keep a record of what you've tried, what worked, and what didn't.

8. Play "Spot the Clip Art" with other designers' work.

BLACK-AND-WHITE LINE ART

Despite the growing use of color in printing, many documents are still printed in black-and-white only. That's why it's important to be able to locate high-quality black-and-white line art.

You'll find a wide range of quality levels in black-and-white clip art. Some of the art doesn't look very good and is not up to designer-level standards. Don't let this discourage you from using black-and-white clip art. Fortunately, there are many superb collections and images to choose from.

The price of black-and-white clip art varies, as well. You can buy thousands of images on one CD-ROM disk for just a few dollars, or you can pay hundreds of dollars for a few hundred images.

Many pieces of black-and-white line art are mixed in with color line art in large collections. There are also separate black-and-white line art-only collections available. Some have been created by converting paper-based illustrations to digital format.

Black-and-white line art collections often revolve around themes: food, holidays, sports, people, and business, to name a few. In the large, multithousand-image collections you can find dozens of images related to a single theme. Smaller collections are usually sold in theme packs.

It is possible to convert a color line art image to black-and-white or grayscale using an image-editing program. The conversion to black-and-white works best on images with only a few colors. If the image has more than a few colors, some of the detail may be lost in the conversion. However, you can get some very interesting looking images by converting color line art to grayscale because shades of gray replace the colors.

This grayscale image was created from a color line art image. The image was opened in an image-editing program and converted to grayscale.

FINDING THE RIGHT BLACK-AND-WHITE LINE ART

You see so much black-and-white clip art in newspapers, it's easy to think that is the only kind of black-and-white art available. Most of this clip art looks like it was drawn or sketched by hand. Some of the images are single items, such as a vase of flowers. Some are whole scene illustrations that convey a message and need little more than a caption to turn them into a complete advertisement.

You don't have to use only this kind of black-and-white clip art. Your choices are more varied than you may know. Complete magazine cartoons and intricate borders and spot illustrations are available, as well as dingbats and symbols, pictographs and silhouettes.

You can even find banners and text boxes in black-and-white clip art collections. These kinds of graphic elements are particularly useful for advertisements, although they can be used in any kind of design.

QUICK TIP

GET CREATIVE

You can create your own banners and text elements using an image-editing program and add them to your clip art collection.

These images are taken from the Dynamic Graphics Electronic Clipper series. They are typical of many black-and-white clip art pieces and look like traditional fine line ink drawings.

Catch the Action

If you do a lot of black-and-white design work, it's worth the time to investigate the many different styles of this kind of clip art. For high-quality versions of the traditional newspaper line art, you can check out the digital versions of clip art from newspaper clip art companies. Dynamic Graphics and Zedcor are two companies that offer digital versions of traditional black-and-white clip art.

Aside from the fine-line drawings typically used in newspaper advertisements, there are other styles of black-and-white clip art images. Some resemble classic wood cuts and are comprised of heavy lines of uneven widths. Another style looks like it was drawn by hand using thick, black magic markers.

CHOOSING BLACK-AND-WHITE LINE ART

Each of these different styles puts its own unique design stamp on the images, carrying with them unconscious associations. For example, a woodcut image makes a casual or folksy impression. When choosing black-and-white line art, pay attention to your first impressions. Go with your gut instinct and select the line art that matches the overall impression you want your design to make.

Because the clip art uses only one color (black), choosing the right pieces can take some time. All the images begin to look the same after you've looked at a few dozen

Not all black-and-white clip art looks like traditional newspaper art. These two images are from Dynamic Graphics collections.

pieces of artwork. It helps to have a clear idea of the type and style of image you want before you start looking through your collections.

Black-and-white images can pack a strong visual punch, and too many of them in a design can weigh the whole thing down. With this in mind, choose carefully and make sure to leave plenty of white space around the images.

You can mix different styles of black-and-white clip art together in one design, but the images should have compatible styles. When in doubt, put the two images side by side on a sheet of paper and look at them. You'll know instantly if you like the combination.

Some collections are scanned images of hand-drawn illustrations and fetch a high price. Such collections can contain interesting images and be good investments. Make sure to ask, though, how the clip art was created before you buy an expensive collection. Unless the images were scanned at a high enough resolution on a good quality scanner, they may not be useful for designs that will be printed at high resolutions.

Vector file images, such as EPS files, are the most versatile kind of black-and-white clip art you can buy. You can resize vector images at will, something particularly important if the black-and-white clip art looks like a fine ink drawing. Raster images created from scans cannot be significantly enlarged without showing breaks in the lines and jagged edges.

If you like a particular raster image, but you're not sure how it will look when imaged at a high resolution, try enlarging it and having the enlarged image output on a high-resolution imagesetter. If the enlarged image looks good, you can use the image at that size or a smaller one with no problems. This is

QUICK TIP

You can use grayscale images in any design that will be printed in black ink only. You don't have to limit yourself to black-and-white line art.

BLACK-AND-WHITE LINE ART

a particularly effective way to test line art with many fine lines in it—but don't reduce it too much or the lines will fill in.

Q U I C K T I P

USE COLORED PAPER

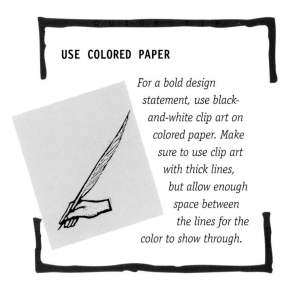

For a bold design statement, use black-and-white clip art on colored paper. Make sure to use clip art with thick lines, but allow enough space between the lines for the color to show through.

BLACK-AND-WHITE CARTOONS

Cartoons are the staple illustration for many publications, including magazines, newsletters, and newspapers. Editorial cartoons still appear on the editorial pages of every major newspaper. The *New Yorker* is famous for entertaining cartoons that convey wryly complex humor in a single panel.

In years past, these cartoons were all drawn by illustrators and cartoonists such as the famous James Thurber and pasted onto the page before the printing plates were made. Today, illustrators create the drawings either on paper or on their computers. If the publication uses digital technology to create its pages, hand-drawn cartoons are sometimes scanned and dropped into the page digitally.

Black-and-white cartoon clip art comes in two forms, the single-panel form and the humorous drawing. In the single-panel form, an entire humorous situation is presented in one panel, often with an included caption. Most of the time you use these cartoons as you find them. You might add some color to them or change the caption to personalize the cartoon for a particular use. Be careful, though—making drastic changes to them can make them less funny.

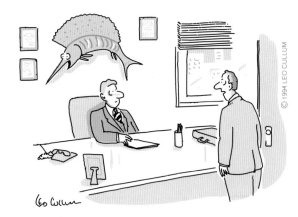

© 1994 LEO CULLUM

"I don't recall any mention of that fish on your resumé."

This black-and-white cartoon presented in a single panel is from the Click Art Famous Magazine Cartoons collection. Some of the cartoons in this collection come with captions, some don't.

Humorous drawings are wonderful additions to any graphic artist's clip art collection. Everyone likes to laugh, and humor can be used to sell, persuade, inform, and entertain. Unless you're a gifted illustrator, cartoon clip art is the way to go.

There are as many different kinds of cartoon clip art styles as there are cartoons. Some cartoons look as if they were drawn by a child. You'll find sleek, sophisticated-looking images and chunky, homespun-looking ones.

You can use these images just as you find them or combine them with others. Since black-and-white clip art cartoons pack even more communications punch than black-and-white line art, you'll have to spend time making sure the total message of the combined cartoons fits your design. You'll also have to make sure the different styles go together if you use cartoons from several collections.

COLORING BLACK-AND-WHITE LINE ART

You can change colors in a clip art image or add multiple colors to a black-and-white image using an image-editing program. You may be wondering why you should take the time to color black-and-white line art when you could use colored line art instead. After all, there are many wonderful pieces of colored line art available. However, it's worth experimenting with coloring black-and-white line art. If you use highly stylized black-and-white line art, you can obtain effects you can't get with colored line art.

It's also worth experimenting with the effect you get by coloring a small element in a complex black-and-white piece of clip art. It's akin to the visual effect some film and television directors create by removing all the color from a movie or video and then digitally adding it back to one or two objects.

There are many different kinds of black-and-white clip art cartoons. These are just a few examples of what's available.

In this before-and-after example, the black-and-white clip art image has been colorized in two ways: using a single color and using multiple colors.

CLIP-ART ORIGINS

The origins of many digital black-and-white clip art images lie in the clip art books used for decades by newspapers. Newspapers only printed in black-and-white until a few years ago, so they needed a steady stream of good black-and-white images. These images were drawn by hand by professional illustrators, printed, and bound into hardcover books. These books were distributed to newspapers by clip art companies that charged royalties for the use of the images.

Whenever the newspaper ad department needed an illustration for an advertisement, a staff member would flip through the clip art book for a suitable image. Once one was found, the staff member would cut it out of the book (clip it) and it would be pasted on the page with the rest of the ad.

With the advent of computerized page-layout, many clip art companies have converted their line art to digital format. Today, most newspaper art is available in digital format, although paper clip art is still used. Many digital black-and-white clip art images are reminiscent of the art used in newspapers.

BEFORE YOU BUY BLACK-AND-WHITE LINE ART

1. Many documents are still printed in black-and-white, so black-and-white clip art comes in handy.

2. Some traditional clip art collections have been turned into digital clip art.

3. Not all black-and-white clip art looks like traditional newspaper clip art.

4. Match the artistic style of the clip art to the overall style of the design.

5. Look for vector images if you want to be able to make the image bigger.

6. Black-and-white cartoons can be used in a variety of different designs.

7. Never pick a cartoon that you don't find funny in some way.

8. You can alter the existing captions of cartoons and replace them with your own.

9. Making too many changes to cartoons can make them less funny.

10. Coloring black-and-white line art can give you some winning images.

Clip art services produced books of clip art—sometimes much bigger than those pictured here—and distributed them to newspapers for use in advertisements.

BLACK-AND-WHITE LINE ART PROJECT/ADVERTISEMENT

When choosing images that will be used in black-and-white, it's important to pick images that work well together. When you use colored images, complementary colors can tie a design together, and image style is not as important; when you use black-and-white clip art, style is most important in tying the whole design together.

If you do a lot of work with one or two colors only, look for collections with many pieces that are designed to be used together, or at least look alike in some way. This will help speed the selection process and make for better-looking designs when using more than one piece of clip art.

In this example of an ad for a telephone book, the images were all selected from the same collection of black-and-white clip art. Notice how they look like they belong together.

Helping Your Child
Succeed is All We Do

Achievement
Learning
Center

123 West Valley Drive
Hopeville, New York
800-TO-LEARN

open 7 am-9pm
Monday-Friday

MAKING IT YOUR OWN: WAYS TO EDIT AND CHANGE

You can use clip art just as you find it. That's certainly the easiest and fastest way to use it. Unfortunately, that isn't always possible or desirable. You like something about it, such as the shape—but you don't care for something else, such as the color. So sometimes you have to put some work into an image before you can use it.

Making changes to an image can be time consuming. So you want to choose the changes carefully, balancing your need to produce the best image with the time it takes to make the changes. One of the ways you can do this more effectively is to be familiar with the differences simple changes make to an image. With enough practice, you'll be able to look at an image and gauge how easily and quickly you can make it look the way you want it.

By combining simple changes such as stretching an image and changing some of the colors, you can change the look of any piece of clip art dramatically. Experiment with two- and three-step changes to come up with a combination of changes that you can use over and over again.

Here are some examples of simple changes you can make to a piece of clip art. Later on in the chapter are examples of the difference more complex changes can make.

AN ORIGINAL START

Always make your changes to a duplicate of the original clip art image. That way, you can always go back to the original image if you're unhappy with your work. Make a copy by duplicating the file before you start working on it or by using the Save As function and saving your work as a new file.

SIMPLE CHANGES

All of these changes can be done using an image-editing program. Most require only one or two quick steps to complete.

Mirroring an image means flipping it so it appears as though you're looking at it in a mirror.

Time flies when you're having fun trying to create a great-looking image. So try to balance the time you spend working on the image with the payoff.

Convert the clip art to a different kind of image. For example, change colored line art to grayscale or to black-and-white.

Rotating an image makes some images look different, but it works best on images with no apparent orientation. This is not a good image to rotate!

Rotate the same image several different ways and cluster them for a new look. Geometric shapes have no apparent orientation, so they can be rotated various amounts and still look good.

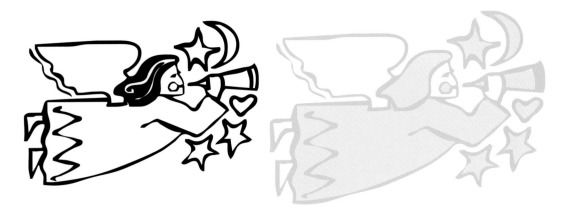

Replace the black in a black-and-white image with another color. You don't have to color every element in the image. In this example, the wings were not filled in although the line color was changed to match the rest of the image.

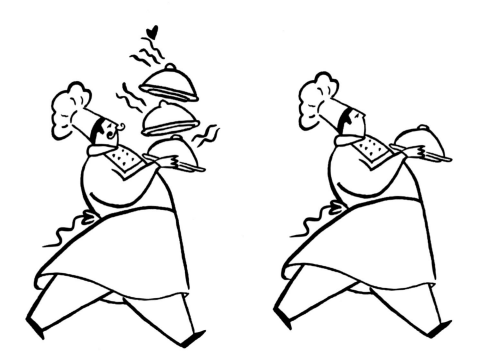

Erase or eliminate part of the image. The more complex the image, the greater a difference eliminating part of it will make. In this example, a few deletions makes a discernible difference.

Stretch or squeeze the image. This change works best with simple images such as geometric shapes and letters. Stretching or squeezing a more complex image can confuse the person looking at the image. They can't quite figure out what they're looking at!

Put the image on a background to give it more punch. In this example, the letter form was first colored and then positioned on a textured background.

Experiment with the special effects available in your image-editing program. The three special effects applied to this image are Ripple, Twirl, and Tiled from Adobe Photoshop.

SPECIAL EFFECTS

Stand-alone programs and plug-ins can help you create spectacular special effects. But before you buy one of these programs, see if you can't create something similar with your image-editing program.

Copy and paste the image several times. Some image-editing programs have step-and-repeat functions you can use to accomplish the same look.

Combine the image with others. Make sure to pick compatible images so they look like they belong in the same group. Change the size of a few images, and leave different amounts of space between the images so the grouping looks more natural. In this example, two pieces of clip art were changed in various ways to make the bottle collection.

MORE COMPLEX CHANGES

Getting the most out of the techniques in this section of the chapter requires experimentation and practice. Part of the practice is for nailing down the skills involved in doing the work. Another part is to stretch your brain to come up with new and creative ways to apply these techniques. With a little effort and repeated use, soon your mind will come up with great new ways to use these two- and three-step procedures. Try to surprise yourself.

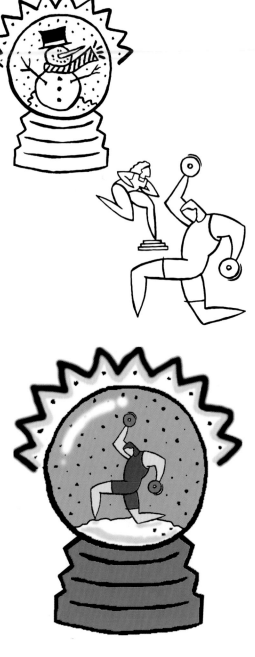

In this image, two pieces of clip art were put together in a draw program. The star image was copied and pasted several times and then layered behind the angel. The resulting image was colored using a paint program.

Two pieces of clip art were combined to create this image, intended to be used as part of an advertisement for a health club. Part of each image was deleted using a paint program. The two were put together in a draw program and saved as one image, which was then colored using a paint program.

*A piece of simple black-and-white line art was
made into an icon for a multimedia or Web page
design. All the changes were made within the
image-editing program, which has extensions
built in for creating borders for images that will
be used as buttons.*

TEN CHANGES YOU CAN MAKE TO CLIP ART

1. Mirror the image.

2. Rotate the image.

3. Convert the image to another type of image.

4. Change some of the colors in the image.

5. Add color to parts of a black-and-white image.

6. Erase or eliminate part of the image.

7. Use special effects to alter the image.

8. Squeeze or stretch the image.

9. Combine the image with others.

10. Combine several simple techniques to radically
change an image.

COLOR LINE ART
AND CARTOONS

Digital color line art ranges in complexity from simple, one-color outline drawings to intricate scientific illustrations. Unfortunately, clip art collections also range in quality; not all color line art is good enough for professional use. Many collections feature material that began as monochrome line art, colorized after scanning. The result looks almost—but not quite—right, in the same way that early attempts at colorizing black-and-white movies are not realistic.

It takes time to find collections of color line art good enough for professional work. They cost more than color line art not intended for professional use, and the collections don't include as many pieces as general-interest and home-use collections. When seeking good clip art, it's a good idea to ask other designers what color line art collections they prefer. Another good way to track down high-quality color artwork is by research—if you see an illustration online or

in a magazine that appeals to your eye, contact the source and find out if the image came from a clip art library.

Companies often offer line art in collections centered around a topic. For example, art is available in categories such as food, occupations, sports, holidays, and history. If you often design graphics around one or more of these themes, buying such a collection is a good idea: it will save time looking through generalized clip art collections to find material to use.

For custom color jobs, another option is applying color to clip art yourself, a potentially time-consuming proposition in Photoshop. Specialized programs such as DS Design's Colorize take the tedium out of the task by instructing the computer to ignore "holes" in the borders between colored areas that are present in bitmap files, a process that allows color to be applied with a "paint can" tool.

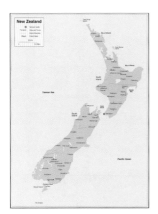
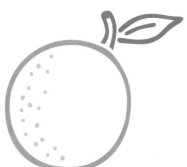

Color line art ranges from the simple to the complex: Here, an orange from T/Maker's Studio Design Group, next to a detailed map of New Zealand from Cartesia Software.

DS Design's Colorize software helps speed the process of applying color to clip art; however, because it works only with bitmapped files, the scalability of finished files is limited.

FINDING THE RIGHT COLOR LINE ART

Color line art often comes mixed with black-and-white line art in CD-ROM collections. Sometimes you'll find two versions of the same image in a collection—one black-and-white, one with color. This variety comes in handy for designs requiring both a mono-chrome and color version.

Q U I C K T I P

COLOR LINE ART AND MULTIMEDIA

Keep on-screen color fidelity in mind; an image that looks won-derful on your monitor can be indecipherable on an older, less sophis-ticated color monitor. Know the equipment the viewer will be using before choosing the color line art. When in doubt, choose simple line art, with few colors.

If you want to use color line art for a project, expect to spend extra time choosing and examining it before using it in a design. Most likely, you'll end up testing a number of collections before finding art good enough for commercial and professional design applica-tions; follow your design instincts when nar-rowing the field.

Q U I C K T I P

FILM AT 11

If artwork consists only of two or three spot colors, you don't need to make a four-color separation plus the spot colors; there is a workaround that does not require the line art to be modified in Photoshop or Illustrator and does not require extra plates. If the number of inks used is equal to the number of spot colors in the line art, designate one color per plate and disregard the CMYK scheme. Make sure the printer is aware of which ink color goes with each plate.

Unless you have time to spend editing and changing complex color clip art (which negates the time savings of choosing clip art over creating an illustration in the first place), it's a good idea to choose simple illustrations. Intricate drawings with lots of colors are difficult to edit into something usable. It is better to look for art that doesn't need editing and can be imported straight from a diskette or CD-ROM.

Before buying a clip art collection, find out how it was created. Doing so helps avoid production problems later on. Beware of clip art scanned at low resolution (300 dots per inch and less), which looks good onscreen and even when printed at low resolution; it reproduces poorly at the high resolution required for film.

ORGANIZING CLIP ART

Sort through collections of clip art and reorganize their pieces to speed locating appropriate pieces. Make smaller collections using a good third-party image catalog utility such as Imspace's Kudo Browser or Show, a Mac freeware program that *can be found on the World Wide Web at http://www.shareware.com. For example, out of a half-dozen collections from different companies, thirty pieces might be related to business. Once your clip art is organized by topic, finding the right illustration becomes fast work.*

COLOR PRINTING AND LINE ART

Until recently, extra costs of color printing kept demand low for color line art. Early clip art was mostly simple, black-and-white illustrations.

Monochrome printing was the norm; color printing was used primarily in books and magazines. Newspapers have only recently begun to incorporate color throughout their publications. Comic sections and color supplements used to be printed separately on different equipment and at higher costs.

Today, while the cost of color printing is still higher than monochrome printing, publishers use it more and more often. As a result, the use of color in clip art is increasing, providing artists with an enormous variety of digital color line art and cartoons to enhance their designs with a minimum of time and expense. This situation should continue to improve as technology (both computer and printing) evolves.

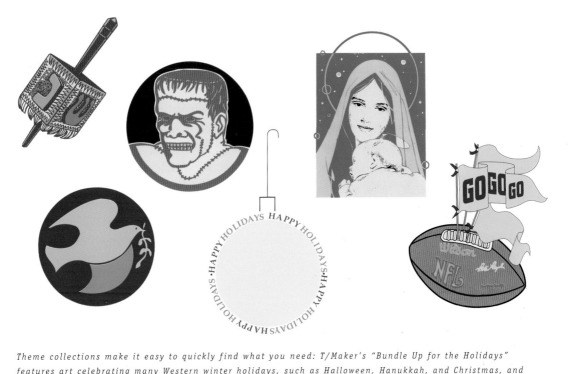

Theme collections make it easy to quickly find what you need: T/Maker's "Bundle Up for the Holidays" features art celebrating many Western winter holidays, such as Halloween, Hanukkah, and Christmas, and less traditional events such as New Year's Eve and Super Bowl Sunday.

Some clip art is drawn, scanned and saved at low resolution, and then converted to EPS format. Scanning to EPS at low resolutions does not usually result in professional-quality art. Images created in this way often are difficult to edit and to print. Choose hand-drawn art scanned into TIFF format at high resolution over hand-drawn art scanned as low-res EPS files; you'll be better off.

If there are doubts whether a certain piece of color line art will output correctly when imaged at high resolution, check the art before using it by importing it into image-editing software and placing it on a page. While it's at actual size, inspect it. Try simple changes such as rotating, resizing, or outlining, and see how the art is affected by those changes—most page-layout programs offer

these features, and good clip art is created with these possible changes in mind.

View the artwork at the highest percentage the software allows without the clip art becoming pixellated, then carefully examine it again. Look for breaks in lines or irregularities in line width. These occur when an image has been scanned at low resolution.

Look at the areas where colors meet lines and where colors meet each other. If there are gaps where lines or colors should be meeting, the artwork might not look right or trap correctly when imaged at the high resolutions that many print jobs demand. If there are places where colors and lines overlap a great deal, the image may have existing traps, which are almost always set improperly. If these problems are not solved in illustration

programs and trapping software—sometimes not all of them can be fixed—the colors will not run together properly in the final printing.

As a final test, have the images test-output on an imagesetter at a high resolution (try it at the final output resolution for the job) and have color proofs made with the films. Low-resolution color proofing devices don't reveal problems that occur at high resolutions, especially trapping quirks.

These precautions are time-consuming and, in some cases, expensive. However, some time and care taken before the illustration is completed saves even more expensive fixes later on—and unhappiness on the part of you or your client.

In printed pieces, color line art looks best when the final output includes process colors. That way, you won't have to modify colors in the line art to match specific spot color inks used in the rest of your design. Color line art reproduces poorly in black-and-white. Use black-and-white art in black-and-white jobs.

Browsing through clip art collections before beginning a project provides design inspiration. It also saves time; it's easier to start with one or two pieces of color line art and build a design around those pieces than it is to find the "perfect" color line art for an in-progress design.

CARTOONS

Cartoons occupy a special place in the minds and tool kits of designers. They pack a visual punch, but choose them carefully—the wrong cartoon undermines the whole design.

No other type of graphic adds so much impact to the meaning of an illustration.

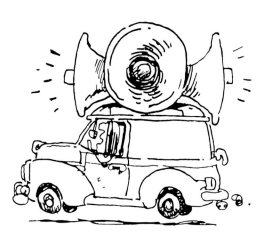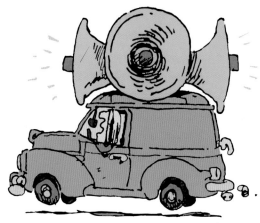

Some cartoons come plain, such as this black-and-white illustration of a car with a public-address system mounted on the roof. Adding color increases the graphic's impact.

Make sure the clip art's resolution meets the resolution requirements of the reproduction size—these children's drawings from DS Design's KidBAG package needed to be reduced at least 50 percent for the publication of this book. Had they run 100 percent in this book, they would appear bitmapped.

Cartoons quickly provoke emotion with readers of print graphics and viewers of multimedia materials. Know your audience, however; the wrong choice will evoke little or no reaction, since cartoons rely upon readers' and viewers' knowledge of a particular culture or event. As if that's not enough to worry about, keep in mind that it's easy to send offensive or confusing messages with cartoons.

A few cartoons usually come with general clip art collections. Specialized cartoon sets, however, have enough variety that they are worth buying. Look for cartoons that are customizable—those with empty speech balloons, open spaces for inserting company brand names, or room to add your own captions are the most useful.

Because comic strips, cartoons, and comic books have always been printed in color, people are used to seeing them in color. Digital clip art cartoons come in color or in black-and-white, and colorizing black-and-white cartoons offers a more modern—or just different—look. The same cautions about choosing and examining color line art apply to cartoons. Most digital cartoons did not start out in a digital format; they were line drawings, often scanned at a low resolution.

CARTOONS

Caricature originated in the sixteenth century, at the art school in Bologna founded by the Carracci family—hence, caricature. Political caricature caught on in eighteenth-century England after the launch of Punch *magazine, which became known world wide for its caricature. In the United States and elsewhere, caricature in social and political criticism spread quickly, although cartoons are also used in magazines such as* Playboy *and* The New Yorker *just to make people laugh.*

Cartoons in the form of comic strips and comic books with their familiar panel arrangements and "speech balloons" originated in the late nineteenth century. Newspaper syndicates in the early 1900s commissioned and sold strips to newspapers, making it possible for one strip to be seen in newspapers across the country. Today, comics and cartoons are staples of newspapers and magazines, published in special sections or sprinkled throughout a publication.

Check the usage rights carefully before investing in clip art cartoons. Some collections are royalty-free, but not copyright-free, and their artwork may be restricted for use in non commercial work. In the case of cartoons drawn by well-known artists, check with the creator or publisher before using them in commercial applications. Make sure you have all the rights you need to publish a design; otherwise, you risk legal liability if you violate copyright, even if you are doing the work for someone else.

When text is added, as in this "library" cartoon, the humor value of a cartoon increases, but the number of appropriate situations to which it can be applied decreases.

BEFORE YOU BUY COLOR LINE ART AND CARTOONS

1. Consider buying theme collections.

2. Match the formality of the graphic to the job.

3. Beware of low-resolution scans.

4. Less detail in the clip art means less fiddling with it in graphics software.

5. Test a demo piece of clip art from a collection in image-editing software before purchasing.

6. When quality counts, run a test with an imagesetter at output resolution.

7. Be aware of your audience when choosing a cartoon; these graphics are sometimes offensive.

8. Magnify—"zoom in" on—a piece of clip art and check for irregularities in line width.

9. Avoid clip art requiring extensive color changes; drawing a graphic from scratch sometimes takes less time.

10. Know the usage rights that come with the purchase of a clip art collection, and make sure you are legally allowed to use the artwork for your specific type of job.

COLOR LINE ART PROJECT/LOGO

Use your imagination when scrolling through clip art collections. This logo for a fictitious crafts festival was created from a single CD-ROM of color line art; the concept of quilt square was kept in mind while scrolling through T/Maker's Studio Series Design Group collection, and the elements shown on this page were selected to assemble the logo.

When choosing color clip art, consider how the colors in each graphic will combine with one another. Avoid making many color changes to artwork; it alters the artist's original intent, diminishing the cohesiveness of a design. Often the best way to ensure good results is to choose art from the same collection or from collections created by the same designers or companies.

The finished design on the next page shows how different pieces of color clip art go together to create a fresh look.

Amish Downs
Fall Crafts Festival

T R O U B L E - F R E E
P R I N T I N G

Most graphic design ends up in print. The type of printer may be inkjet, laser printer, digital press, or offset press. But sooner or later . . .

No one has done any studies on how often it occurs, but every graphic artist is familiar with Murphy's Law as it affects printing: Whatever can go wrong will go wrong more often than seems possible. And once in a while, things that printed perfectly the first, second, and third times will not print correctly the fourth time.

Nothing is more frustrating than looking at a beautiful design on-screen that won't print. A close second, though, is the frustration of looking at an inkjet or laser printer proof of a design that will not print on an imagesetter or digital press.

Graphic artists need to learn how to cope with and solve some of the most common printing problems related to graphics files and clip art. Being able to cope with problems such as files that won't print eliminates headaches of all kinds. Learning how to check traps and troubleshoot problem files makes for happier clients and a more profitable bottom line.

The information in this chapter relates primarily to printing on a PostScript device (Level 1 and Level 2). If you don't have a PostScript printer, don't worry. The general information about keeping things simple and some of the hints will work with non-PostScript printers, as well.

FASTER PRINT SPEEDS

Graphic-intensive files always take longer to print than text files and sometimes longer than would seem possible! Usually the printing time increases with the number of images in the file, but a single, extremely complex image can take a long time to print as well.

You don't have to reduce the number of images in a file to make the file print faster. Keep one basic in mind: Simplify, simplify, simplify. Whenever and wherever possible, make designs simpler before printing them.

Every graphic artist knows the effect of Murphy's Law on printing. What can go wrong will go wrong.

This doesn't rule out wonderfully intricate and interesting designs. It only means thinking about how to feed the printer the amount of information it needs—nothing more and nothing less.

One way to do this is to make as many changes as possible to clip art before importing it into a page-layout program; for example, rotate the artwork in an image-editing program rather than in the page-layout document, or reduce the amount of data imported into your design by sizing your art in an image-editing program.

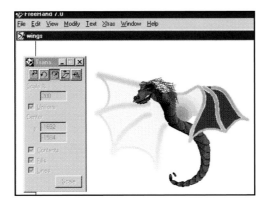

Size your images in an image-editing or paint program before you import them into your page-layout program.

QUICK TIP

THINKING AHEAD

Size images before placing them in a page-layout file; otherwise, when it's time to print the file, the page-layout program "remembers" the original image and has to resize it, a two-step operation. It's simpler if the page-layout program only has to work with the resized image.

Here are some other ways to simplify a piece of clip art before importing it into a page-layout program.

When working with a high-resolution scan or bitmap graphic, use Photoshop or another image-editing program to reduce the resolution to match the print resolution. Don't use a 600 dpi bitmap if the file will be printed only on a 300 dpi inkjet printer.

Reduce the amount of information in EPS clip art and other EPS graphics by importing them into FreeHand and applying the Simplify Path command. Do this to each graphic before importing it into the page-layout program. FreeHand will go through the graphic and reduce the number of points in a path while keeping the same shape. The image will look the same, but it will require less computing power and time to image.

QUICK TIP

SIMPLIFYING YOUR CLIP ART

Subselect an individual path (Alt+click or Option-click) if it's part of a blend and has text attached to it or inside of it, and then apply the simplify path command. Experiment with the amount of acceptable variation from the original path. Larger values alter the shape more than smaller values.

Avoid layering images inside the page-layout program. Sometimes one image covers part of another. For faster printing, edit these images and combine them into one image before you import them. There will be less

information imported into the page-layout program and less information going out to the printer.

Ungroup objects before printing the file. Grouping objects is a great way to create a design, especially for copying and pasting images, but grouped images take more time to print than ungrouped ones. Before downloading the file to the printer, select the images and ungroup them. Save the file immediately to avoid making any inadvertent changes to the design.

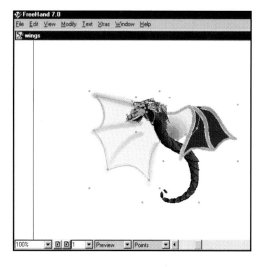

Reduce printing times by ungrouping objects before printing the file.

You can inadvertently increase the complexity of a file by embedding EPS files in another image or by using clip art with embedded EPS files. A single image may be composed of several EPS images, such as a logo and a few pieces of clip art. Unless you know how the files were created, you'll need to use a printing utility to ferret out this problem.

IT WON'T PRINT!

Simplifying a file before printing it will definitely speed up your print times. However, there will still be times when the file won't print at all. Here are some of the reasons why a file won't print and some suggestions.

LET'S FACE IT, SOMETIMES YOU KNOW YOU'VE GONE A BIT OVERBOARD.

So if the file is too complex:

1. Print the file at a lower resolution (start at about half). If it prints at a lower resolution, try suggestions 2 and 3.

2. Reduce the complexity of the design by applying the simplifying techniques outlined in this chapter.

3. Print the file on an imagesetter or printer that has more memory.

Troubleshooting PostScript files only seems like rolling dice. You can solve most problems using these tips.

Try printing a proof of the file (select Proof in the Print Document dialog box). If the file prints, it will print everything but the graphics. The graphics will be represented by squares or rectangles. One of the graphics may be causing the problem. Remove one of them at a time and try printing the file until you locate the problem images.

Place a potentially troublesome graphic on a page by itself. Try printing it. If it won't print, use another image.

If you suspect a particular graphic is causing a problem, place it on a page by itself and try printing it. Start with the most complex graphic and systematically isolate the one causing the problem.

Eliminate that graphic. If you have to use it, open it in the application that created it (if you know) and resave it in the same format. Or open the image in an image-editing or drawing program and resave it in various formats, including the one it's in now.

Do yourself a favor and take some time to save some time. Put the image back on a page by itself and try printing it alone before putting it back in the design.

When you don't know (or don't care) what the problem is, try printing the file one separation and/or one page at a time. This approach avoids many memory and complexity issues.

Finally, there is the old standby of turning the printer off and turning it back on again. This is the kinder, gentler version of giving the device a swift kick in its memory banks.

Or, you can always turn the printer off and go home.

to troubleshoot the problem. If the printer prints the file up to the point it encounters the error and then prints an error message, you'll know exactly where the printer is encountering difficulties.

EXAMINING THIRD-PARTY UTILITIES

Two kinds of third-party printing utilities are useful for figuring out what's going on with a file that won't print.

The first kind is a preflight utility program. This kind of program will preprocess a PostScript file and display it on-screen. If the image is visible on-screen, chances are it will print without a problem. Trouble-free printing isn't guaranteed, but preflighting a file is a good way to check it before trying to print it. Many service bureaus preflight every file before printing. If the utility can't process your file, it will print a list of error messages. Use these error messages to figure out what's wrong with the file. Unfortunately, no program can fix the errors, but these will point the way.

Preflight programs usually have other features that make them useful even if printing problems never arise. For example, they can determine what fonts are used in the file—even those in embedded EPS files.

A PostScript error handler is another printing utility. Some error handlers are available as third-party utilities. Some page-layout applications, such as PageMaker, come with one.

Download a PostScript error handler to the printer, then print the file. If the utility prints out an error message, use the message

TRAPPING CLIP ART

As discussed in chapter 5, problems in trapping sometimes arise with colored clip art, which isn't always trapped properly—so be sure to check the traps before printing color separations.

One way to check the traps on a piece of colored line art is to enlarge it in image-editing program. Look at the areas where colors meet. Look for gaps between colors.

One way to check for improper traps is to print a color proof of the image before incorporating it into the design. Print several images at one time to save money, and look closely at the color proof to check for improper traps. Use a magnifying loupe if necessary.

If a file is not trapped properly, the trap can sometimes be fixed with minor edits. You can also use third-party trapping software to adjust the traps.

Should you trap your own clip art, or, for that matter, your own designs? It depends on who you talk to. Some designers don't believe printers have enough time or expertise to trap files properly. Some printers would prefer to get files from designers completely untrapped and do the trapping themselves.

If you are comfortable with the theory and practice of trapping, talk to your clients and the printer about doing your own trapping. If the printer doesn't have the time or the expertise to do the trapping, doing it yourself ensures that it will be done to your satisfaction. Last-minute trapping changes may have to be made, but at least the basic traps will be set. Ask your client and printer to let you know if they alter the traps later.

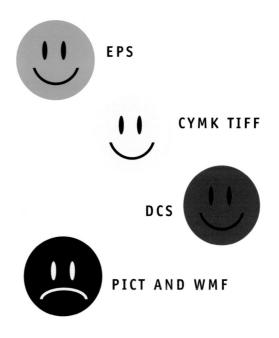

EPS

CYMK TIFF

DCS

PICT AND WMF

SEPARATION ANXIETY

Sometimes clip art images won't separate properly—break down the image into process or spot colors—for four-or six-color printing. The entire image ends up on the black plate or the CMYK percentages aren't correct. Before using clip art for designs that will be output on an imagesetter, check the file format of the graphic and make sure it's in one of the formats Adobe recommends for high-resolution work: EPS, DCS, or CMYK TIFF. File formats such as PICT and WMF were created for file transfer purposes, not for high-resolution output, which four- and six-color process printing often entails. Convert these files to one of the recommended formats before using them for high-resolution work.

Avoid using the clipboard to bring images into a file from another program. No matter what the original file format was, the clipboard often translates the file into a bitmap format. On Windows PCs, the clipboard will usually translate the file into a Windows bitmap (BMP) or WMF file. On the Macintosh, the file is often turned into a bitmap or vector PICT.

Bitmap images sometimes won't separate, appearing as composite images on the black plate. Vector images sometimes separate in ways other than the way you want. To catch problems like this early, print out the color separations on a laser printer or inkjet printer. Later, when the design is finished, check again by having a color proof made with the film separations.

INCLUDING IMAGES IN THE FILE

To link or not to link, that is the question. Page-layout programs like PageMaker offer the option of including a copy of each graphic in the file or creating a link to the graphic (also referred to as "referencing"). What's the best approach?

Linking graphics files to a PostScript file gives you smaller file sizes overall. Smaller files mean faster file opening times and more nimble responses from the computer overall. But there's a disadvantage, too.

When printing a file, the computer sends the printer the separate image files along with the page-layout file. If you move the image file after you create the link, the image may not print properly. The computer will use a low-resolution screen version of the artwork.

Including images in a page-layout file creates one large composite file. Missing or damaged links aren't a problem, because the images and layout file are in one large file. Including images in a file can increase the overall size of the file considerably. For example, adding a 150 KB graphic to a file can increase the file by 200 KB or more, depending how the application handles the file.

Link clip art and graphic files to a layout unless you're using many different images.

Decide which approach works best for your situation after experimenting with both approaches. However, here's the rule of thumb for faster printing: keep the total number of bytes going to the printer as low as possible.

BEFORE YOU PRINT OR GO HOME

1. For faster printing, simplify clip art designs before importing them into a page-layout program. Keep file sizes to a minimum.

2. Simplify a file by ungrouping objects before printing and make all changes to a piece of clip art before importing it into a page-layout program.

3. If a file won't print, try printing it at a lower resolution. If you think a piece of clip art may be the problem, try printing that piece separately.

4. If the lights on the printer blink and the file downloads, but nothing prints, check to make sure the right PPD is installed.

5. Try printing the file one page or one separation at a time.

6. Use a preflight utility program or PostScript error handler to help you figure out what's wrong with the file.

7. Use links if you're working with more than a few pieces of clip art or the files measure in the megabytes. Otherwise, make your life easier by including the images in the file.

8. Check the traps in colored clip art used for color separations.

9. Avoid using the clipboard to import graphics.

10. For high-resolution color separations, use EPS, DCS, or CMYK TIFF files only.

OBJECT PHOTOGRAPHY

Object photography is one of the coolest things to happen to clip art in a long time. It's new and it's exciting—it offers graphic designers a whole new way of working with clip art images.

Object photography images are photorealistic images of objects without a background. The object looks as though it was clipped out of a photograph, which in some cases is actually what happened. The image was digitally removed from a scan of a real photograph and a digital file of the object was created using an image-editing program.

Another way to create an object photography image is to render a photorealistic image of an object using computer modeling software. Such images resemble real objects, but they never existed anywhere outside of a computer! A wide variety of these kinds of images is available, including both cartoonish and hauntingly realistic images.

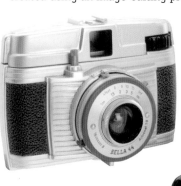

These are object photography images from Classic PIO Partners and Dynamic Graphics. They are all photographs of real objects with the backgrounds removed digitally.

detailed and so real you would think they were created by astronauts or spy satellites snapping photographs as they circle the Earth. They are really computer-generated illustrations created from cartographic data.

Photorealistic images of our planet and photorealistic maps are types of computer-generated object photography images.

Some object photography images such as this one are created in a computer with modeling software.

Object photography collections are usually collections of images related to objects: cameras, shoes, household items, and so on. However, some collections have been created by applying the same computer techniques to shots of people. These images are photographs of people without backgrounds.

There are even a few out-of-this world photorealistic map collections that you can use as clip art. These images are fantastically

You can also purchase object photography images of people. You get a photograph of a person without a background and place it against any background you choose. Think of the possibilities!

OBJECT PHOTOGRAPHY

Object photography images are not the same as stock photography images, although stock photography companies also create and sell object photography collections. Stock photographic images are complete images—objects with backgrounds.

As object photography becomes more popular with graphic artists, more and more clip art and stock photography companies are creating collections. There's a great selection now, but since object photography is such a big hit with designers, you'll have an even better selection in the years to come.

WHERE TO SEARCH

Look for object photography collections in graphic arts catalogs and at trade shows. Clip art companies and stock photography companies are creating object photography collections, so ask your favorite clip art company if they have any. Always ask if the images were created from photographs taken by professional photographers; you'll get better-looking images if they were.

HOW OBJECT PHOTOGRAPHY OBJECTS ARE CREATED

Without computers and image-editing programs, it would be much harder to create object photography images. You'd have to physically trim the rest of a photograph away from the object you want and then paste the object onto your design. It's been done, but the result is usually less than aesthetically pleasing.

Object photography images of real objects are created using scanned photographs of objects against a simple background. Once the photograph is scanned, the background of the image is deleted, leaving only the object.

SHOOT YOUR OWN

An easy way to create your own object photography images is to photograph objects against a background that has none of the same colors in the object. When you've digitized the photograph, you can use an image-editing program to remove everything in the image that is the color of the background.

To create photorealistic images of objects that don't really exist takes a lot of skill and a lot of computing power. Special image creation and modeling software programs are used first to create a basic model of the image. Then the same programs are used to apply textures, colors, and even shadow effects.

Object photography images created from real objects are usually TIFF files, since they were created from scanned images. Photorealistic images created in a computer are usually vector files.

object photography image can be a few megabytes or larger. When you edit object photography images, especially highly detailed color images, you'll need to use a computer with lots of memory and lots of free hard disk space. For example, colorizing a map image in an image-editing program can require 20 or so megabytes of RAM and 50 or so megabytes of free hard disk space.

Look for collections with high-resolution and low-resolution versions of the images on the same disk. Use the low-resolution versions in your preliminary designs and in any projects that will only be

USING OBJECT PHOTOGRAPHY IMAGES

You'll need two things to make the best of object photography images: experience working with photographic images and a lot of computing power. Because of their photorealistic nature, object photography images look and feel more like photographs in a design than like other kinds of clip art.

Having a lot of computing power helps because the images are so large. The file size of a small black-and-white line art file can range from a few bytes to a few hundred bytes. The high-resolution version of a small

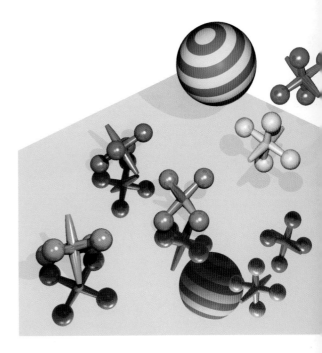

If you look closely at some computer-generated photorealistic images, you'll see shadow details. These details help foster the feeling that you're looking at a noncomputer-generated image.

OBJECT PHOTOGRAPHY

seen on-screen. Save the high-resolution ones for printed documents that require the higher resolution for greater print quality.

The low-resolution version of this image is on the top and the high-resolution version is on the bottom. The low-resolution version is 272 kilobytes and the high-resolution one is 2.39 megabytes.

Some collections have images of the same object shot from two or more different angles, such as a straight-on view and a side view. If you want to create a series of related designs, such collections can be useful. For the first design you could use the straight-on view, and for the second one you could use the other view.

EDITING AND PRINTING

You can use image-editing tools to change object photography images. Whatever software you use must be capable of manipulating large amounts of image data. Otherwise, you either won't be able to obtain the results you'd like, or you won't even be able to edit the image.

Before you buy or use an object photography image, make sure it has enough resolution to look good when it's printed. You need

less resolution for a brochure that will be reproduced on a photocopier than you need for a full-color brochure that will be printed on an offset printing press.

You can enlarge most object photography images without seeing degradation in the image—not because they are special bitmap files, but because the images are scanned at such a high resolution in the first place. If you are enlarging an image by several hundred percent, you can use an image-editing program to add pixels to the image to reduce the amount of degradation in the image's quality. This process is called "resampling up" in many programs.

When in doubt as to how an image will reproduce, you can copy it onto film using an imagesetter to make a color proof. To get the most information out of this test, place the same image on the page several times and apply different line screens to it.

Treat object photography images as you would treat other pieces of clip art. You can mix them with other images, including non-object photography images. You can delete parts of several images and "glue" the edited images together to form something unique. This is especially fun if you want to create something that couldn't be real. The photorealistic look of the resulting image is a real attention-getter.

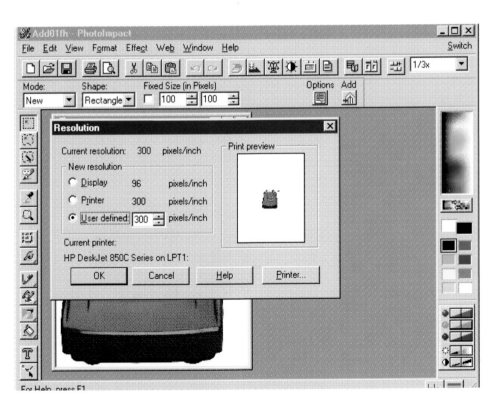

You can change the resolution of an image with an image-editing program. This program has several options, and you can also type in any resolution you like.

OBJECT PHOTOGRAPHY

It was only a few years ago—1994—that Classic PIO Partners debuted one of the first digital collections of object photography images. Taking advantage of the fact that more and more companies were using computers to create documents, the company (then named Ridgley Curry and Associates) decided it would be cool to make it easy for designers to use photorealistic images in digital layouts. They had the technology; the only problem was finding objects people would want to buy pictures of.

The company formed a partnership with 20th Century Props, a Hollywood prop house with warehouses of old "stuff" that had been used in movies, such as telephones, radios, cameras, kitchen appliances, even lighting fixtures. The resulting twelve CD-ROM collections helped launch the digital object photography business.

No Maltese Falcon in this collection, but how about a hula girl from the Classic PIO Partners collection of nostalgic memorabilia?

These two images of a radio and a toaster were edited and joined to create the resulting image of a radio toaster. The color of the new object was changed to blend the two objects together visually.

Experiment with object photography images by applying the different photographic special effects available in image-editing tools. Treat object photography images as you would any photographic image—have some fun with them.

A different special effect was applied to each of these object photography images. In the first, the globe image was flattened and fattened. In the second, the microphone image was made to look more like a drawing.

BEFORE YOU BUY OBJECT PHOTOGRAPHY

1. Find out how the images were created. Did a professional photographer take the shots?

2. Look for collections of objects. Don't forget about images of people and planets.

3. Buy collections with high-resolution and low-resolution versions of the same image.

4. If you're creating a series of designs, consider collections with multiple views of the same image.

5. If the image was computer-generated, make sure it looks real to you. Check for shadow details and realistic colors and textures.

6. Buy collections that have many images related to a single theme. You'll get more use out of the collection.

7. Look for collections that directly relate to the design work you do most of the time.

8. Have some fun experimenting with changes in the image.

9. Don't enlarge the images too much unless you resample them up in an image-editing program. Use the low-resolution version of the image for all mock-ups and preliminary design work.

OBJECT PHOTOGRAPHY PROJECT/BOOK COVER

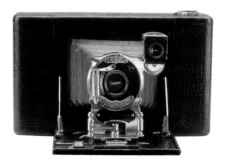

Object photography is one of the newest and most exciting kinds of clip art. It always brings a fresh new look to any design. If you can find an appropriate image for the message you're trying to convey, object photography can help you do it in a memorable way.

Take special care when selecting object photography images. For print projects, you want the highest quality scanned images so you can use the image as is or resample it down to fit the resolution of the printed piece. For projects that will be viewed on-screen, you want to use images that work well when reduced.

Don't be afraid to experiment with the images, either. In this example, the artist chose only one piece of object photography (an antique camera) and applied some special effects, creating a book cover design. He copied and pasted the image and then applied a stipple effect with his image-editing software. In doing so, he added an air of mystery to the design without allowing the camera image to dominate the title of the work.

obscura

the exposure of deception

michael stone

BORDERS, PICTURE FONTS, AND LETTER GRAPHICS

Borders and picture fonts are more akin to basic pictorial elements than any other kind of clip art. Unlike cartoons and line art images that convey specific visual messages, borders and picture fonts are less specific. Some of them are even abstract.

For these reasons, borders and picture fonts convey more subtle visual meaning. Like a frame or a piece of decorative molding, borders don't communicate the actual message, but they can enhance it.

Borders are primarily linear images. They can be line drawings or object photography images. Frames are a type of border. Instead of running across the page or down one side of it, they frame an entire page or an element on the page.

Letter graphics are pieces of clip art that look like single letters. Like borders, they enhance designs. They can also be the first letter in a body of text. They are not true text characters generated with a word processor or page-layout program; they're images like any other piece of clip art.

You'll find many different categories of borders and letter graphics and just as wide a range of image quality. Even inexpensive col-

Picture fonts are the same as other fonts—each keystroke is a different graphic. These come from DS Design's dingBRATS font.

Letter graphics look like pieces of type, but they're really clip art images. You can find them in many general collections of clip art and in specialized collections.

As you can see, there are many different kinds of borders and frames. These examples were taken from several different clip art collections.

lections of clip art usually include at least a few border images. There are also high-quality stand-alone collections of borders and letter graphics that look as though they were drawn by hand and meticulously colored.

There are black-and-white and color line art borders, as well as photorealistic borders. Borders come in ready-made frames and as separate elements. A collection of clip art that has borders in it usually contains some letter graphics as well.

The best place to find a good selection of high-quality borders and letter graphics is in stand-alone collections. You'll find at most only a few borders and letter graphics in large, general collections. Look for collections in graphic arts catalogs and at trade shows.

If you are interested in design elements for a certain look, search for them in stand-alone thematic collections. You can also find decorative elements collections, which include borders and letter graphics, in various styles, including Art Deco and Art Nouveau images.

When you're looking through your clip art for a suitable border, keep in mind that you can always create your own borders by using the "step and repeat" feature in your draw program to make multiple copies of a single object or group of objects. Create a line of images, group the images, and save them as a single image. If you save the file in vector format, you can resize the image as desired.

BORDERS YOU CAN MAKE YOURSELF

You can create a bar border by clipping a thin rectangular shape out of a stock photograph or even a segment of another piece of clip art. You can also fill rectangular shapes with textures, solid colors, or fine lines.

CHOOSING BORDERS AND LETTER GRAPHICS

Since you often have to resize borders and letter graphics, try to find them in vector file formats, such as EPS and WMF. There are some lovely borders in raster image formats, such as TIFF, but you will have to be careful not to enlarge them too much.

Choose borders and letter graphics that are layered images. That way, you can remove part of the border and incorporate it in other parts of the design. You'll also find it's easier to selectively color parts of a border or frame if it's layered.

When you searching for a border, keep the entire design and design style in mind. Look for borders that match the style of your design. If the rest of the design is light and airy, choose a light and airy border; using one made of heavy, bold lines will clash with the rest of the design.

These border elements are part of a collection of Celtic clip art. Specialized image collections are good sources of unusual-looking borders and alphabet fonts.

ALPHABET SOUP

If you need borders, picture fonts, and letter graphics frequently, consider making your own minicollection by gathering up all of them from your clip art library. It will be faster to look through the minicollection than to look at the whole library.

A clip art frame and a clip art image were merged to create this image. The frame was selected because it matches the style and colors of the design of the image inside it.

USING BORDERS AND LETTER GRAPHICS

You won't find a lot of advice on how to incorporate borders and letter graphics into designs in most graphic arts books. Maybe this is because many designers think of them as nondescript image blobs you drop into designs almost as an afterthought.

Shame on them! Although you don't want the border to be the first thing anyone notices about your designs or the only thing they remember, borders and letter graphics can add to the beauty and functionality of your designs.

The best overall design advice for borders it to use them sparingly. When they are overused, they can overwhelm a design and disrupt the meaning. Build in plenty of white around borders and picture fonts unless you want the border to act as a frame.

The same advice applies to letter graphics. A little goes a long way with these single images. Think of them as punctuation marks for designs. When used most effectively, they regulate and control the flow of meaning in a design.

BORDERS DON'T HAVE TO BE STRAIGHT LINES.

With an image-editing program, you can wrap a border around a circle or a line you've drawn freehand. This simple idea is a powerful tool for creating new pieces of clip art and for creating coordinating elements you can embody in a series of designs.

To make borders unobtrusive, blend them into designs. One way you can blend a border into a design is to chose one or more colors from the design and put those colors in the border. Another way is to combine a single clip art image with a compatible frame or border. Position the single clip art image in one corner as a visual anchor for the design. Yet another way is to select one element from the image and use it to create an entire border.

You can draw attention to a portion of a design by putting a frame around the area you want to highlight. This technique is particularly effective if the area inside the frame is a different color than the area outside of it.

Text was placed inside a ready-made frame inside this clip art image.

QUICK TIP

USE A BORDER TO FRAME AN IMAGE.

Combine the image and frame in an image-editing program. Make sure the frame is slightly smaller than the image. Using the edges of the frame as a mask, delete any part of the image that does not fit in the frame.

If your design will be printed in color, experiment with different looks by placing the border on a colored background. Tread lightly with this approach, because the resulting border can easily become too distracting. Use borders like these as the only clip art element on the page.

Borders are useful for stationery. Select a border with various elements, split up the elements, and use them to coordinate business cards, letterhead, and envelopes.

Coordinate pages in multipage designs using borders, picture fonts, and letter graphics. Or you can use them to distinguish one section of a document from another. The same border, picture, font, or letter graphic placed in the same place on each page of the document ties the whole design together. A different graphic for each section put in the same place on the page distinguishes one section from another.

This circular border was created by clipping part of another clip art image. The original image was opened in an image-editing program and clipped to create this unusual border.

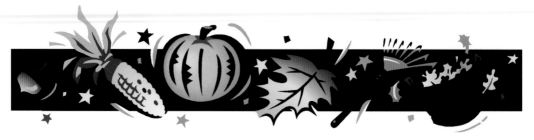

This border with images placed along a colored rectangle comes ready made in a collection of colored line art from Dynamic Graphics. This kind of border draws a lot of attention.

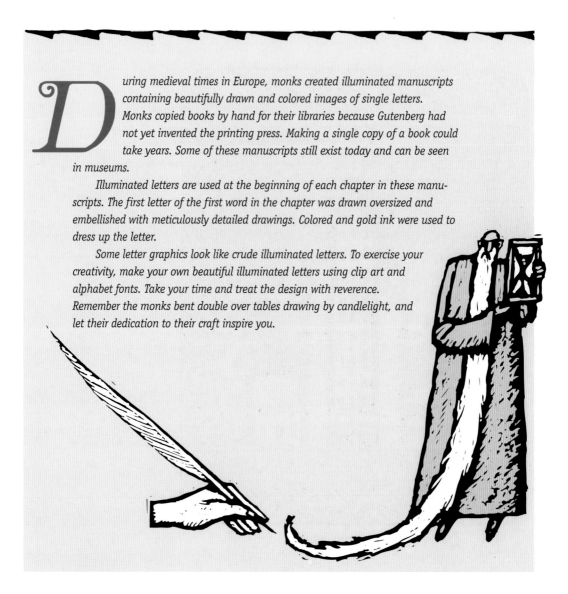

D*uring medieval times in Europe, monks created illuminated manuscripts containing beautifully drawn and colored images of single letters. Monks copied books by hand for their libraries because Gutenberg had not yet invented the printing press. Making a single copy of a book could take years. Some of these manuscripts still exist today and can be seen in museums.*

Illuminated letters are used at the beginning of each chapter in these manuscripts. The first letter of the first word in the chapter was drawn oversized and embellished with meticulously detailed drawings. Colored and gold ink were used to dress up the letter.

Some letter graphics look like crude illuminated letters. To exercise your creativity, make your own beautiful illuminated letters using clip art and alphabet fonts. Take your time and treat the design with reverence. Remember the monks bent double over tables drawing by candlelight, and let their dedication to their craft inspire you.

BEFORE YOU BUY BORDERS, PICTURE FONTS, AND LETTER GRAPHICS

1. Borders, picture fonts, and letter graphics should be unobtrusive.

2. Choose borders, picture fonts, and letter graphics that match the style of your design.

3. Borders, picture fonts, and letter graphics come in black-and-white and colored designs.

4. You can create your own borders by clipping parts of other images.

5. Use borders, picture fonts, and letter graphics sparingly with plenty of white space around them.

6. Stand-alone collections of borders, picture fonts, and letter graphics are the best sources for these images.

7. Experiment with techniques for blending borders, picture fonts, and letter graphics into your designs.

8. Borders can be made into circles and other non-linear images.

9. Picture fonts and letter graphics work like punctuation marks to direct the flow of a design.

10. Look for borders, picture fonts, and letter graphics that will enhance your designs.

BORDER PROJECT/
BUSINESS STATIONERY

Borders and small pieces of clip art can be used in many different kinds of design projects. They are especially useful as decorative elements. Rarely are they bold or different enough to be able to carry the entire weight of a design—if you want to project a strong message.

When it comes to designing stationery including letterhead, business cards, envelopes and labels, borders really come into their own. In this application, the message you want people to pay attention to most—the content—is added later. The design should not dominate; instead it should enhance or reinforce the subtler messages of tone and style.

In this example, only a few pieces of clip art were required to create a very effective series of designs for business stationery.

La Tene Designs

9876 Irish Circle Anytown CA 98765 (123)456-7890

La Tene Designs

9876 Irish Circle Anytown CA 98765

(123)456-7890

La Tene Designs

Graphic arts, logos

9876 Irish Circle
Anytown CA 98765
(123)456-7890

BEFORE YOU BUY

Let's face it. You're going to buy a lot of clip art over a lifetime of working your craft. You won't have just a collection or two of clip art. No one collection, no matter how good or how big it is, will be enough to satisfy your creative requirements. So you'll be continually adding to your archive of clip art images— which means you need to do some planning and budgeting.

Think of your archive as a wardrobe. You have some clothing (images) in your closet. Some of the items are worn out or out of fashion. You need to replace some items and maybe branch out a little, change your style a little.

Clip art is a lot like clothing. You need some basic items and some items you only use for special occasions. Variety is the spice of life and of design.

Before you rush off to the computer store or order something from a catalog, inventory your collection. Look at the quality and kinds of images you have (black-and-white line art, color line art, object photography, borders). Some gaps will be immediately apparent. Some won't be as obvious.

What you need to have on hand has a lot to do with the kind of design work you do on a regular basis. If you do a lot of small advertisements for newspapers, you'll need some serviceable black-and-white line art. If you do newsletter and magazine layouts, you'll need more colored line art and maybe some photorealistic images.

Once you know what you have, you can make up a shopping list to round out your wardrobe. Buy what you need first, no matter how tempting some collections can be. That mink coat may be awfully enticing, but you don't need one if you live year-round in Miami. Look for images that coordinate with images you already have. Buy these first, and add specialty item collections later.

Unless you do a lot of work for astronomers, you won't use much clip art like this image. Buy images that fit the kind of work you do.

Be ruthless about getting rid of the images you don't need or haven't used in years. If you can't bear to throw them away, copy them to a backup tape and store them away. Keep only the collections that are truly usable.

Tech-M's clip art has its own special feel.

QUICK TIP

BUILDING YOUR IMAGE WARDROBE

Then there are those beautifully crafted images that catch your eye and that you can't imagine living without. Treat yourself to some of these from time to time, but don't try to build your whole image wardrobe around them. You'll need the more conventional images most often.

Borders and picture fonts are accessory items. They are part of almost all the large clip art collections. There are also stand-alone collections of high-quality borders and alphabet fonts. Once you've filled out the major gaps in your clip art wardrobe, start adding some of these collections. You'll find uses for them you never imagined.

Borders and picture fonts often serve as accessories for designs. They punctuate the communication flow. Buy specialty collections of these after you've got a good collection of basic items.

SHOPPING FOR CLIP ART

Graphic arts catalogs, trade magazines, and trade shows are all good places to scout for clip art collections. Computer stores often sell a few of the larger collections of clip art, megapacks containing tens of thousands of images. Don't overlook these; they can be good foundation collections.

Unlike clothing, you can try clip art images on by trying a few samples, but you can't take clip art back for a refund. Once you've broken the seal on the package, the collection is not returnable. If a collection catches your eye but you're not sure about spending the money, see if you can get a few free samples.

Some clip art companies offer sampler disks. Others have posted images on their Web page for you to download and try. Even if the ad or catalog doesn't specifically mention samples, call the company and explain your purpose. They may send you a few images on a disk.

As with clothing, there are couture lines of clip art created by clip art companies that specialize in creating top-of-the-line clip art. These images are often stunning and command a high asking price. They're often worth every penny, as well, if you can afford them.

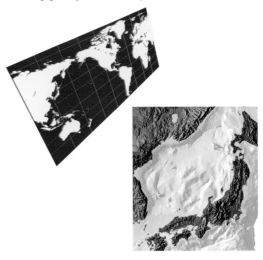

Once you break the seal on the disk package, a collection of clip art is all yours. Make sure it meets your needs before you open it.

These cartographic images are from various collections by Digital Wisdom and Cartesia. Creating one of these images takes hours of time. If you need images like these, investing in such a collection is worth the money.

Clip art companies usually have more than one collection of clip art, just as clothing manufacturers have more than one line of clothing. If you see a collection you like, ask the company for a complete catalog of their products. Once you're familiar with a brand of clip art, you'll be more comfortable buying other collections from that company.

Ask your friends about the clip art they've purchased and used. Ask them what they like and don't like about the different collections. You can even borrow a few images to try them, but sharing collections is a legal no-no. Support the clip art industry and buy a collection if you're going to use the images frequently.

Talk to other designers and artists who use clip art. Brainstorm a little about the kinds of images you need to have.

Look for collections with image file formats that work best for you. A little experimentation will help you establish which ones you need. Vector images are elastic, one-size-fits-all images. They can be stretched and shaped at will without risking image distortion. Raster images are not as flexible. They are more like custom-fitted clothing, designed

to be used at the size they were created. Stretch them too much and the buttons pop off.

FIND OUT BEFORE YOU BUY

When you're shopping for clip art collections, keep in mind a list of questions you'll need answered before you sign on the dotted line. The text on the package or in the ad will answer some of these questions. For other answer you may have to call or write the clip art company directly.

Since you're trying to round out your image wardrobe and buy only new images, ask how many pieces of clip art in a certain collection have been used in previous collections. Some clip art companies break their larger collections into smaller ones and sell all of the collections simultaneously. Ask before you buy.

Do a little research about clip art collections before you buy expensive ones. Call the company that makes the collection to find out how it was made, what file formats the image use, and what computer platform versions exist.

Find out for what computer platform the images were designed. Some image collections are only available in Macintosh format. Others work only with Windows PCs. This happens more often than you would think. Some collections have versions for both platforms. You want the collection that works with your computer.

Along with the platform, determine what file formats are used for the images. It's possible to use all the different file formats clip art is made in, but some are easier than others. Some collections have a variety of file formats on one disk, which makes them much more versatile than others. What you don't want to do is buy a collection only to find out it only comes in FreeHand format and you don't have FreeHand! You may be able to import these images into your page-layout program, but you won't be able to edit them.

Ask questions about how the clip art was created. This is the kind of information you're not likely to see in catalogs or on boxes. You'll have to ask the company that sells the collection or read about the collection in magazine articles. Knowing how the clip art was created tells you a lot about its quality level.

Find out how the clip art was created. Images that were hand-drawn by famous illustrators and artists and then scanned on high-resolution scanners are often excellent investments.

If you know each image was drawn by hand by a famous illustrator and then scanned on a high-resolution scanner, you can rest assured you'll be getting excellent images. If it sounds as though the images were created by novice illustrators working on an assembly line, sample a few before you buy!

The only exception to this would be the collection of clip art that is so inexpensive you feel you can't go wrong buying it. Fair warning, though, the art on the outside of the box often looks much better than the images on the disk inside.

THE BUYER'S GUIDE

The Buyer's Guide at the end of this book is a full-color guide to some of the best digital clip art available. The section is arranged alphabetically by clip art company. Within each company section is a brief description of some of the collections offered. There are also many full-color examples of some of the clip art offered by these companies.

Browse through the Guide at your leisure. If you see something you like, call the company to ask about the entire collection. Contact information—addresses and telephone numbers—is included for each company.

Needless to say, there are far more clip art collections than those showcased in this book. You could fill an entire volume with examples of the clip art available to designers. This section is a small slice of what's on the market, but it's still a wonderful treat.

VIEWERS AND OTHER USEFUL TOOLS

No graphic artist should be without a software tool kit that includes several different utilities for using clip art images. Viewers are the most commonly used clip art utility. They allow you to browse through clip art collections without first importing the images.

File translation utilities allow you to convert one type of file to another, say a PCX file to a TIFF file.

Image-editing software is a must-have when working with clip art on a regular basis. It's useful even if you only want to make simple changes. Without a good set of image-editing tools you really can't get the most out of your clip art collections.

Image database programs are also important to have if you use clip art collections on a regular basis. Image database programs are covered extensively in chapter 12.

Some kinds of clip art utilities, such as image-editing programs, can be found wherever software is sold. Others, such as file translation utilities, are not as popular, so you'll have to look for them on bulletin boards, on on-line forums and in graphic arts and software catalogs. There are some good graphic arts shareware programs you can try, as well.

VIEWERS

Viewers are the neat pieces of software that allow you to look at thumbnails (smaller-than-life images) of your clip art on-screen. Many clip art collections come with viewers. There are also third-party viewers you can use with a variety of clip art packages and file formats.

All viewers allow you to look at the images without opening them in your image-editing or page-layout software. Without viewers, in order to look at and choose clip art, you'd have to import images into your page-layout or image-editing program one at a time. Viewer software enables you to browse and choose images much faster than importing them one at a time into another program.

Viewers help you save time while looking for the perfect piece of clip art for your design.

With a viewer, you can see at a glance which images have color in them and which don't. If the collection is a mixed bag of image types such as colored line art, object photography, and black-and-white line art, you can quickly pick out the types of images you want.

Most viewers do little more than show you the thumbnails, arranging them on the screen in a way that looks like a family photo album. Some present all the images related to one category at once. Others show you a few of the images at a time and you browse through them in no particular order.

This is the viewer that comes with a collection of inexpensive clip art. Using one screen, it shows all the images related to a single theme.

Other viewers that come with clip art collections are more sophisticated and offer features found in image database software. You can view multimedia files, search for a particular image by type or file name, and add or delete images to the collection. Some viewers even have slide show capabilities.

If you deal with a lot of clip art images from different sources, investigate the variety of third-party image viewers. That way, you can use one really good viewer for all your clip art collections and won't have to install a new viewer every time you get a new collection of images.

There are a number of shareware viewer programs for both PCs and Macintosh computers. Make sure to get a program that can display a wide variety of file formats, including vector and raster formats.

Sometimes clip art collections will come with printed catalogs of the images, as well. These printed catalogs work well as long as the clip art publisher makes the images large enough on the page so you can see them!

Some viewers come with extensive search and retrieval features. With this viewer you can search for images using a keyword.

FILE TRANSLATION UTILITIES

File translation utilities and graphic conversion programs are wonderful magic boxes. You import a file in one format and export it in another? You have only TIFF files and the service bureau takes only EPS files? No problem, if you have a good file conversion program.

Like viewers, file translation utilities are handy to have around when you're working with a lot of clip art and other graphic images. Even though you can convert a file by other means, if you convert images routinely or need to do a bunch at one time, a file translation utility is the way to go.

As you might expect, these utilities are not big sellers in the retail computer software business. Look for them where you find shareware programs or check in graphic arts trade magazines for reviews of utilities. They are also often listed in software product catalogs.

File conversion capabilities are built into many image-editing programs. Open the file and use the Save As or Export features to save the file format you need.

IMAGE-EDITING TOOLS

Some clip art images are perfect just as they are, especially the more expensive collections. You don't need to change anything; you can import them as is into your page-layout program. With other images you can see that making a small change, such as the color, would make a better, more suitable image. Others need extensive changes to make them useful.

To change a piece of clip art, use an image-editing software package. These tools let you make a variety of changes to the image, including rotating it, erasing part of it, and combining it with other images.

The tool kit of any graphic artist isn't complete without at least one of these programs. If you do a lot of work with images, invest money in one of the sophisticated, expensive programs. Leverage your investment by learning all you can about how the software works, either through training courses or training videos.

Of course, you can always work your way through the tutorials in the manual! The idea is to spend time getting to know what the software can do and to figure out how to do it before you actually need to use these features.

Image-editing programs differ from draw and paint programs, although these can be useful tools, as well. Drawing programs allow you to create an image from scratch, as you would draw an image on a blank piece of paper. Paint and coloring programs let you add color and details to an existing image.

To make this image look different, we changed the color of some of its elements using an image-editing program.

FUNCTIONS AND FEATURES

As you can imagine, there's a lot of overlap between image-editing, draw, and paint programs. Look for a program that gives you a lot of the artistic functions you need, and forget about the category of software to which the package belongs.

Because of the amount of overlap between functions in different applications, it doesn't make sense to describe each major image-editing software tool here. Instead, look for these major features and functions when selecting an image-editing program.

Image-editing features are those that allow you to make changes to an image that you've imported. These features include cut and paste, clipping tools, and erasers. Look for a zoom tool that lets you zero in on the area you want to edit and zoom out again to normal view once you've finished.

Along with image-editing features such as cut and paste and erase, the ability to undo a change is a basic feature. Much more desirable is the ability to undo multiple times, each time undoing a change until you have gotten back to the original image. Only the most sophisticated programs have unlimited undo capability, so you'll probably have to settle for multiple undos.

Drawing tools allow you to add to an existing drawing or create a new one. These tools are usually separate items on the tool bar, with individual tools for drawing circles, squares, straight lines, and curved lines. The more sophisticated tools allow you to control the width of the stroke and the color.

Look for basic image-editing features: cut, paste, clip, and erase.

Look for programs that will let you draw so you can add elements to the clip art image.

Choose programs with tools for changing the color of an image, either globally or a drop at a time.

The ability to arrange one portion of an image or to layer different images is a must-have feature when dealing with clip art. Without layering, you are reduced to having to erase portions of images you want to hide, leading to all sorts of problems down the line if you want to change the layering effect.

You'll want tools that allow you to change the color of an object globally (easily convert the whole image to another color) or to change the color of selected portions of an object. It's also really nice to be able to pick colors from one portion of an image and use them in others.

Any program you choose should be able to import a variety of file formats. You may decide to work with only a few types of graphic images, such as TIFF and EPS. However, you may see something you like that is only available in some other type of file format, so you need some import flexibility.

Some image-editing programs have other nice features, although they are not so mainstream as to be found in many image-editing programs. These less commonly used features can be found in graphic arts suites, as plug-ins or as standalone programs. They include the ability to add depth to an image (make it 3-D) or add textures. Morphing tools are also fun to use. Autotrace programs are useful for changing bitmap images into vector graphics.

TOP TEN TIPS FOR WORKING WITH
VIEWERS AND OTHER TOOLS

1. Buy a clip art collection for the quality of the images, not for the included viewer. Viewers are nice to have, but what's really important is the art itself.

2. Viewers are useful tools for looking at images before you use them.

3. Buy a third-party viewer or use one viewer for managing multiple collections. That way you don't have to install a new viewer for every collection.

4. Acquire and get to know one good file translation utility before you need to use it. Have someone else verify that a test translation worked by importing the file into a program you don't use.

5. Look for clip art utilities wherever you get shareware programs, such as bulletin boards, on-line forums, and even Web sites for computer magazines.

6. Keep the shareware concept alive by paying for your software in a timely fashion.

7. Check out the image-editing capabilities of a drawing or coloring program. Make sure it has the features you need. You may need to buy more than one program to get every feature you want.

8. You may have to use several image-editing programs to make significant changes to an image, but make as many changes as you can in one program.

9. Drawing programs let you create images from scratch using basic drawing shapes (circles, boxes, straight lines, and curved lines).

10. Paint programs let you add color to an image or change existing colors.

YOUR RIGHTS
AND THEIRS

Any graphic designer using clip art to create designs for commercial use has to understand some basic legal concepts, including copyright, licensing agreements, and royalties. Knowing about all these topics won't help you be a better artist, but it will help you be a better business person.

Copyright is a big topic. Entire books have been written about it. It's also an important one to graphic artists and designers around the world. It's the best way to protect yourself against unauthorized use of your work.

Copyright laws and practice vary from country to country, so you should at least be familiar with the copyright law in your country. If you sell your work internationally, try to learn something about how copyright works in other countries. Trade organizations and publications are good sources for information about copyright as it relates to your work.

LEGAL ADVICE

The information presented in this chapter should not be construed as legal advice. Contact a lawyer who specializes in working with authors and artists for advice specific to your situation.

In the United States, your design is copyrighted the moment it's complete. The person who creates a work of art, takes a photograph, or writes an essay owns the copyright. It starts immediately and doesn't need to be registered. You can, and should, place the familiar © symbol on your works, along with the year the work was created and your name.

If you sell your work, it's a good idea to register your copyright with the U.S. Copyright Office before the sale happens. This becomes important if you ever want to sue a person or a company for violating your copyright. You can get the necessary forms and instructions from the Copyright Office. Information is also available on-line (http://lcweb.loc.gov/copyright/). There is a small fee for registering a copyright.

Copyright laws vary from country to country. Designers should be familiar with the basic copyright laws of their own countries.

In the United States, copyright owners have considerable protection under the law. Your rights are strengthened when you register your copyright with the Copyright Office.

As the copyright owner you can sell or give away one, some, or all of these rights. Clients often ask for the copyrights along with the design as part of the fee they pay for your work. Problems can arise if you and the client haven't negotiated the rights before the sale is made.

Clients often do not understand the exact rights you, the creator, are conveying as part of the fee. For example, the fees paid to content creators normally cover a one-time-only use. Clients may not understand that unless they have negotiated up-front and paid for multiple use of the work, they cannot use it more than once.

To help forestall unfortunate misunderstandings, some artists have developed their own licensing agreements similar to those found on software packages and clip art collections. It's a good idea to include a simple statement along with your design that clearly spells out what rights you are granting your client. It's an even better idea to spell this out in some kind of written contract before you begin work.

IN THE UNITED STATES, THE OWNER OF A COPYRIGHT HAS THE FOLLOWING RIGHTS:

- the right to copy your work, including the right to photocopy it,
- the right to produce derivative works,
- the right to perform the work publicly (as in a play),
- the right to display your work,
- the right to prevent someone else from claiming they created the work,
- the right to prevent others from creating slightly different versions of your work and putting their or your names on it.

© 1992, 1994 HENRY MARTIN

ACCOUNTS PAYABLE

ACCOUNTS RECEIVABLE

ACCOUNTS JUGGLED

Using your own licensing agreement can help prevent problems before they start.

COPYRIGHT AND CLIP ART

Clip art companies almost always retain the copyrights to their designs. They grant you, the purchaser and user of the clip art, certain rights via a licensing agreement. These rights vary from collection to collection, even when you are using collections from the same company.

Some restrictions you may encounter sound like they are taken from software licenses—digital clip art is one form of software, after all. You may not be able to install or use the collection on more than one computer at a time. You may not be able to copy the collection, except to make a backup copy.

Make sure you read and understand the restrictions in the end-user license before you buy a collection of clip art.

Clip art companies sometimes impose restrictions on how you can use clip art even if it is royalty-free. The licensing agreement should tell you about those restrictions.

You may also encounter restrictions on the use of the images for creating designs. You may be able to use or change the images only for printed materials, not for on-line or multimedia designs. You may not be able to use the image on a T-shirt or poster for resale.

With so many possible restrictions, check the licensing agreement on the clip art package carefully before you buy it. This is especially important if you are going to sell the design you create with the clip art.

Sometimes the legalese on the package is so complex you won't be able to decide if you'll be able to use the images as you intend. If so, it's a good idea to write a letter to the clip art company describing your project. Ask them to send you a letter telling you it's okay to use their images for a particular project.

When you create a design using clip art, you own the copyright to your design only, not to the clip art used in the design. So you can't convey the rights to the clip art to your client. Including a statement to this effect in your licensing agreement is a good way to protect yourself against copyright lawsuits.

It's always a good idea to talk with clients about the usage rights they are purchasing from you. Put the agreement in writing before you start a project.

WHAT ROYALTY-FREE MEANS

Although many stock image companies have been forced to give up this practice, it used to be standard operating procedure for these companies to charge for the use of their images. These royalties were like rental fees. You paid every time you used the image.

Some stock image companies, including some clip art companies, still charge such a fee. However, with digital images it's hard to keep accurate tallies. So many clip art companies now make their images available without a fee. That's what royalty-free means.

The catch is, not all uses of clip art are royalty-free. Even if the packaging says the images are royalty-free, check the licensing agreement. Call the company if you can't find this information in the licensing agreement. All of these precautions are particularly important if your design is part of something that will be manufactured and sold, even by a nonprofit organization. The clip art company may want to charge a royalty for the use of their clip art in such cases.

QUICK TIP

QUICK CHECK

Keep the licensing agreements for your clip art collections. Check your rights before you use the clip art from a particular collection for a new project.

TEN COPYRIGHT REALITIES TO KEEP IN MIND

1. You need to know the basics of copyright law in your country.

2. In the United States, your work is copyrighted the minute you finish a design.

3. Always include the copyright symbol, your name, and the year the design was created on all your work. The copyright symbol (©) is part of the character or symbol set in most typefaces.

4. Negotiate the usage rights with your client before you start a project.

5. Write your own licensing agreement and send a copy out with each design, even if you have a contract.

6. When you have a legal question, it's a good idea to talk to a lawyer who's familiar with the legal issues facing creative folk.

7. When you buy a collection of clip art, you're not buying the copyright to the images.

8. Read, understand, and keep the licensing agreement for your clip art.

9. Royalty-free isn't royalty-free for all uses.

10. Get it in writing.

MANAGING COLLECTIONS

I never counted them all, but I estimate that in the course of writing this book, I amassed a collection of nearly a hundred thousand clip art images. One collection had 65,000 images in it. In the end, I had a stack of more than thirty different CD-ROMs!

Graphic artists who use clip art on a regular basis have collections as large as mine or larger. It's not difficult to create such a collection over the course of several years and dozens of projects. I'm sure there are graphic artists who have entire closets full of clip art CD-ROMs. Keeping track of what you have and where it is can be a full-time occupation when you have so many images on hand.

Even if your collection is more modest and includes only a few CD-ROMs, you still need to have some kind of collection management scheme. Even a few CD-ROMs can add up to thousands of images.

In addition to the images you purchase, you also create your own clip art as you edit and change existing images. You'll want to keep these images catalogued so you can use them again.

If your design work includes any multimedia or Web design, you may also have stock video clips, audio clips, and still photographic collections. The CD-ROMs for these elements could fill up another closet.

No matter what, you're going to end up collecting a lot of digital clip art images for your work. You need to get organized.

You need some way to organize and catalog these images and multimedia elements. You'll also need some way to put your hands on them quickly so you don't waste time shuffling through disks looking for the one image you remember you saw somewhere.

There are both low-tech and high-tech ways of getting and staying organized. For smaller collections, you don't need anything expensive. For larger collections, you will need some image management software and possibly some additional hardware.

Take the time to write down your ideas for managing your collections. Decide how you would use such a system and the benefits you'd derive from it.

There are low-tech and high-tech ways to organize clip art collections. For some of them you don't even need a computer (well, maybe it would help a little).

If you don't already have an image management system in place, now is the time to start. You'll need to design the scheme, implement it, and periodically update it. All this effort does take time, time you won't have to spend on creating designs. However, it will spare you hours of frustration later on when you've got to find the right image and you don't have a lot of time to search for it.

A good image management system, whether it's low-tech or high-tech, has three characteristics. All are necessary for an effective system and must be taken into consideration when you are designing your system. Use these characteristics to help you evaluate a ready-to-use image database system or to create your own.

Like anything you do on a regular basis, if you hope to keep doing it for a long time, it must be easy to do. If you have an image management system that's cumbersome and slow to use, you'll stop using it. It's that simple.

So make sure it's easy for you to create and maintain the collection. Make sure it's easy to add images, categorize images, and delete images. Make sure it's easy to use the system. The search mechanism (either manual or computerized) should be so simple that you don't need a manual or documentation to use it. If you create the system, it should be just as easy for others to understand and use.

Make sure your image management system is easy to understand and use. No one wants to be forced to use something he or she can't fully comprehend.

You should be able to enter basic information about the image, such as the name of the company from which you got the image, the name of the collection, the image's name, file format, and file size. You should also be able to enter other information you consider important, such as the projects on which the image was used.

Finally, you must have a backup plan and a disaster recovery plan in place. You're going to spend valuable time creating the collection information and the collections themselves. Spend a little time before the disaster so if it comes you won't be completely derailed.

SIMPLE, LOW-TECH WAYS TO MANAGE COLLECTIONS

Now that you understand what to look for in an image management system, here are some low-tech ways to manage smaller collections. They work if you have only a few CD-ROMs and are worth taking the time to create. When you have more than a few disks, it's time to consider some more sophisticated solutions.

You shouldn't have to keep awake counting your clip art images, when the right database software can effectively do it for you.

The first system is the easiest to create. To get started, print out the directory of the files on each CD-ROM you have, one sheet per collection. Put all the sheets together in one place, such as a notebook. If the collection comes with a book showing the images, keep the book with the notebook. Whenever you get a new CD-ROM, one of the first things you do is to print out the list and pop it in the notebook. It's a simple and quick system.

Using a few sheets of paper, you can create inventories of your clip art collection that will help you be more productive.

This method will enable you to quickly scan the contents of a disk without having to load the disk in your computer. It works best when the images on the disk are labeled with descriptive names, such as Cat, Moon, and Spoon. It doesn't work as well when the image names are not descriptive, such as 0137AB. You'll also be able to find out what file formats are on the disk and the sizes of the files.

The major drawback to this system is unless you have a book or printout of the images on the disk, you won't know what the images look like. You can print the images out on paper, but you'll have to add the image names yourself. If the disk holds thousands of images, such a procedure can take much more time than it's worth. You're better off using the list to guide you to a likely sounding name and using a viewer to scroll through the images on the disk.

You also won't be able to keep track of how the images were used (what project, when, were they altered, etc.). If you want to do that, you'll have to keep separate notes. You could list on a sheet of paper the names and sources of the images used in a project and keep that with the other papers, or you could design a simple form to fill out when you complete a project to slip in with the other papers in the project folder.

You can search through your different collections and create your own visual guide to the images you use most often.

If you find yourself using many of the same images over and over again, print only those images out onto sheets of paper. Some viewers have print capabilities, so you could create simple collections of images you use often and print out thumbnails of the collections. Keep these printouts with the lists of files. If your memory fails one day, you'll be able to flip through the sheets to find the image you're looking for when you can't remember what collection it is in.

With a good viewer, you can quickly scan a clip art collection to find images that fit with the design you're creating.

JUST TO BE SAFE

You can also keep printouts of your completed design projects and label them with the names and sources of the clip art images used for those projects. It's easy to forget what images you used, and sometimes you need to find and use them again later.

Another simple way to manage collections is to use the viewer software that comes with many collections. When combined with your own experience with the different collections, the list of what's on the CD-ROM will help you figure out which disk most likely has the image you want.

Using the viewer software, you can skim through the various images and locate the one or two most likely ones. Look at them with the viewer and write down the names of the images you'd like to use.

TIME TO PLAN

Look for all the images you need for a *project all at once, rather than making repeated forays to find images as you work on the design. Make a shopping list and stick to it. You'll save time because you won't be loading and unloading CD-ROMs throughout the design process.*

Some viewers allow you to construct new minicollections or to create a new album of images. You can add images from one disk or from several. This feature comes in handy if you use the same images over and over again, say for a series of related projects. You can create your own album and keep it on your hard disk.

You can also create small theme collections from a variety of different collections. For example, if you do a lot of design work for restaurants, you could create a restaurant and food clip art collection. Browse through your clip art disks and gather all the restaurant and food clip art into a new collection.

Create your own collections of clip art by creating albums inside of viewers. Look for clip art images that can be used for the same kinds of designs.

You can also use viewers to create albums of the clip art you've created by altering images. Don't forget to keep track of these images, because you want to re-use them if you can. It will save you time later on.

HIGH-TECH SOFTWARE TO MANAGE COLLECTIONS

If you have more than a few clip art CD-ROMs, you may need a high-tech image management system. If you have more than a dozen disks that you use all the time, or you're not the only person who uses them, you definitely need some high-tech wizardry.

High-tech ways of keeping track of your image collections are a good idea if you've got lots of images to manage or more than one or two people use the collection.

First, you'll need some specialized image management software to handle lots of images. You'll also need some heavy-duty hardware, such as high-capacity hard drives or removable media.

Most of this software and hardware is readily available either from your local computer store or from mail-order catalogs. Some of the more specialized items can be purchased from value added resellers or graphic arts distributors. You can even hire someone to come in and set up a whole system for you.

You can set up an image management system by buying different pieces of the system and setting it up yourself.

There are several kinds of image management software programs: viewers, regular databases that support non-ASCII files, object or image databases, and collection management systems. The one you choose is based on how complicated and sophisticated a system you need to have.

Viewers are the simplest and offer only basic management capabilities. They are meant more for viewing images than for managing them. With some, you can search for images by keyword and add and delete images. You can't add information about the image.

Most databases are only capable of accepting text (ASCII) information. Some databases accept non-ASCII files, such as image files and even multimedia files. You can tag each one of these files with a text description, which allows you to add the information you've decided you need to keep. You may or may not be able to view the images on-screen.

Object databases are databases that can keep track of more than text. You can also track non-ASCII files, such as still images, video clips, and audio clips. You get all the search and retrieval features of a database, plus the ability to keep all sorts of files in the database. These programs usually have built-in viewers and players so you can see or play files you retrieve.

Several kinds of databases can be used to keep track of images. All of them allow you to search for images and add new ones to your archive.

Collection management systems have all the power of object databases, plus built-in reporting and tracking capabilities. You can do true management tasks, such as assign images to categories and automatically keep track of when an image is used and who used it.

There is a lot of overlap in the functionality of databases, object databases, and collection management software. It's hard to distinguish between them sometimes or to understand why a particular program fits into one category and not another. Don't restrict yourself to one particular category of software.

Look for the program that's the closest match to your requirements and wishes.

If you share images among several people, look into network versions of these programs. By using a network version of the software, several people can access the same image database at the same time. You'll be able to hook your image server or CD-ROM jukebox to your network and use the images as a central resource.

HIGH-TECH HARDWARE FOR MANAGING COLLECTIONS

First, you have to have a CD-ROM drive. No doubt about it. Hardly any of today's digital clip art comes on floppy disk. The files sizes are simply too big. So if you don't have a quad-speed or faster CD-ROM drive, put it at the top of your equipment acquisition list.

Second, you've got to have some place to store all the clip art you've collected. That means you've got to dedicate some hardware to the cause. What hardware you use depends upon the image management software you use. Your choice can also be influenced by whether the images need to be available to more than one person.

If you're using one of the low-tech management systems and you work alone, the easiest choice is to leave the clip art on the CD-ROMs it came on. You'll be shuffling disks in and out of your computer, but it's less expensive to do this than to load all those images onto a hard disk.

If you have the money to invest in a large (a gigabyte or more) hard disk, you may find it easier to load the images onto the hard disk. Because hard disks are faster at loading images into your computer than CD-ROM drives, you'll get to your images faster. You'll also be able to avoid a lot of disk-swapping.

If you want to make the image database accessible to others via a network, use external hard disks or hard disks attached to network servers. You can even use a separate image server with multiple internal and external hard disks for "megacollections."

If the images will be used by several people on a network, it's a good idea to set up some kind of image protection system. You may want to limit access to certain images (such as corporate logos) to only a few people. You can do this by keeping those images in certain directories or folders and assigning user access privileges with your network software.

Another reason to protect images is to prevent accidental changes or deletions. A WORM (Write Once, Read Many Times) disk is a good idea for protecting images. Once the image is loaded, it can be downloaded, but the original cannot be changed or deleted.

If you want to have a flexible on-line system, you can use removable media and CD-ROM jukeboxes. High-capacity removable media cartridges of a gigabyte or more allow you to keep a lot of images on one cartridge. You can use removable media to hold images

If more than one person uses the images for one project, it's a good idea to set up an image protection system to avoid accidental deletions and changes to the images.

being used for specific projects; once the projects are completed, the images are deleted or archived as needed. The total amount of storage space you have is limited only to the number of cartridges you have.

If you want to keep the clip art on the CD-ROM disks it came on, but you want to have instant access to many disks, a CD-ROM jukebox is a good idea. A jukebox holds many CD-ROM disks at one time. Using a jukebox avoids shuffling disks in and out of your computer. If it is attached to a network, the disks can be kept in one spot and everyone on the network can use them.

You can use CD-ROM recordable technology to archive completed projects or to save edited clip art. You need a CD-ROM recorder, software, and blank CD-ROM disks to do this, but complete systems are now less expensive than entry-level computers.

With CD-ROM recordable equipment, you can create your own collections of images. Use these for internal use only if you are working with images from clip art collections. Check the licensing agreement for information on how you can use the images in a collection.

When you load the contents of several CD-ROMs onto a hard disk, make separate folders for each CD-ROM drive. Name the folders so you can remember the source of the image. Different collections have different usage rights, so you'll need to know which collection the image is from.

BACKUP PLANS AND DISASTER RECOVERY SYSTEMS

Nothing works right 100 percent of the time, especially where computers are involved. After you've put all this time and effort into organizing your clip art collections, you need to protect your investment with a backup plan and a disaster recovery system.

Nothing works correctly all the time, and computer equipment is no exception. Working out the details of your backup plans and disaster recovery systems before major problems occur saves endless confusion.

Having a good backup plan means you know exactly what you'll do in case you have problems. It doesn't have to be complicated, but it does help to be specific. For example, what would you do if your CD-ROM drive stopped functioning? Are you prepared to be up and running again in twenty-four hours? How would you do that?

A good backup plan also means having a good backup system in place. It basically means have two (or more) of everything important available at all times. Here's an easy example: Don't give your clip art CD-ROMs away once you load everything onto a hard disk. Do regular system backups of your clip art collections.

A disaster recovery plan is more extensive and detailed than a backup plan. It requires you to imagine the worst and then create a plan to deal with it. What would you do if a virulent computer virus got loose on your network? What would you do if your office building burned down? Hopefully, none of the horrible things you imagine will come to pass, but even if one does, you need to be prepared to keep your business functioning.

TEN TIPS FOR MANAGING COLLECTIONS

1. Even if you only have a few clip art collections, you need some kind of image management system.

2. Image management systems don't have to be complicated or expensive.

3. You can create image management systems on your own.

4. Viewers can be used for some image management functions.

5. Databases, image or object databases, and image management software are high-tech software solutions for clip art collections.

6. Whatever image management solution you choose, it must be easy to use and easy to understand—for everyone who uses it.

7. You can use various hardware solutions for image collections, including hard disks, removable media, and CD-ROM jukeboxes.

8. If others need to use the same images, consider a network solution.

9. Use some kind of image protection system for shared images.

10. Plan for the worst and hope for the best. Have a backup plan and a disaster recovery plan in place.

BUYER'S GUIDE

Welcome to a visual feast of clip art. The clip art collections featured on the following pages represent the tremendous assortment of clip art images available to graphic artists. Some of the artwork is explored further on the CD-ROM; others have Web pages and product information available on request. Tuck your napkin under your chin, take your time in the buffet line, and enjoy.

Along with the images themselves, you will find general information about each clip art company and details about specific collections. You'll also see contact information for each company. When you contact a company, make sure to ask about other collections—not only are companies constantly releasing new material, but space in this section was limited to just a few pieces per vendor.

A Bit Better Corporation
127 Second Street
Ste. 2
Los Altos, CA 94022
(415) 948-4766
(415) 917-0151 fax
http://www.bitbetter.com

This company creates and distributes humorous pictographs of human beings it has dubbed Screen Beans. Imagine coffee beans with arms and legs and you're starting to understand. There are three collections of Screen Beans, including Managing People, Project Management, and Sales and Marketing.

Aridi Computer Graphics
P.O. Box 797702
Dallas, TX 75739
(800) 755-6441
(214) 404-9172 fax

Aridi's unusual and interesting images come from several different collections of iconic clip art, including borders, backgrounds, letters, and various ornamental images.

Cartesia Software
5 South Main St.
Box 757
Lambertville, NJ 08530
(609) 397-1611

Cartesia Software makes some of the finest cartographic clip art images available. The company has several different map styles, including the MapArt Designer series. All of the maps are fully editable and are built with the graphic artist in mind. All the map features are in layers for easy editing and come in a variety of file formats. All the images are royalty-free.

© Cartesia Software

© Cartesia Software

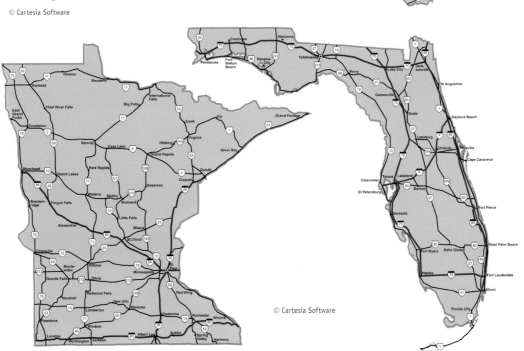

© Cartesia Software

Classic PIO Partners
87 East Green St.
Ste. 309
Pasadena, CA 91105
(818) 564-8106
(800) 370-2746 order desk
classicpio@aol.com (e-mail)

Classic PIO Partners helped launch the object photography clip art market a few years ago with a collection of object photography images called Classic PIO Sampler. It is the leading developer and publisher of nostalgic-theme, royalty-free object photography collections on CD-ROM.

Each collection contains twenty unique objects, each in two views, for a total of forty images. Collections include the Sampler Set, Radios, Telephones, Microphones, Nostalgic Memorabilia, Business Equipment, Entertainment, and Fabrics.

Each image contains an alpha channel mask and precisely hand-edited clipping path, so you can silhouette the image against the background of your choice. All the photographs are taken by professional photographers and then scanned with a high-quality drum scanner. Low-resolution and high-resolution versions of the images are available. Macintosh and Windows file formats are supported.

©Classic PIO Partners

©Classic PIO Partners

©Classic PIO Partners

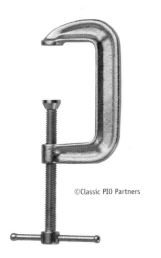

©Classic PIO Partners

Corel Corporation
1600 Carling Ave.
Ottawa, Ontario
Canada K1Z 8R7
(800) 772-6735
http://www.corel.com

Corel Corporation is the creator and distributor of many graphics software applications, including Corel Ventura, CorelDraw, and Photo-Paint. The company includes clip art and image collections with these software packages, but several clip art collections are available separately. For example, Corel Gallery for Macintosh includes more than ten thousand high quality, color PICT clip art images.

©Classic PIO Partners

Digital Wisdom, Inc.
300 Jeanette Drive
Tappahannock, VA 22560-2070
(800) 800-8560 phone
(804) 758-0670 phone
(804) 758-4512 fax
http://www.digiwis.com

Digital Wisdom is a small multimedia and image development company that makes some of the finest map and photographic image clip art available today. Images supplied by the company are used regularly by CNN, network news programs, and even the government.

The company constantly is adding new collections to its product line, so it's a good idea to check the Web page regularly for new additions. Here are brief descriptions of three collections:

GlobeShots

If ever you wanted a take-your-breath-away shot of the Earth from "out there," this is the place. GlobeShots is a collection of 250 colored globes with a variety of backgrounds and special effects. The collection is available on CD-ROM only and contains both high- and low-resolution bitmap graphics in TIFF, PCT, and BMP formats. The purchase price includes the license to reproduce the images.

©Digital Wisdom (Globe Shots)

©Digital Wisdom (Globe Shots)

©Digital Wisdom (Globe Shots)

Body Shots

Tired of the same old business images? Try Body Shots. This collection comprises more than three hundred TIFF images of men and women in various business-related poses. Each image is colored on a white background. The collection is royalty-free.

© Digital Wisdom (Body Shots)

© Digital Wisdom (Body Shots)

Cool Maps

The name says it all. Each volume in this (planned) twenty-volume collection of world and country maps has 240 royalty-free images on it. The images were created by a graphic artist and cartographic designers. Each map has a different theme or style, including fabric, metal, and wood effects. Each volume is available in either JPEG or EPS format.

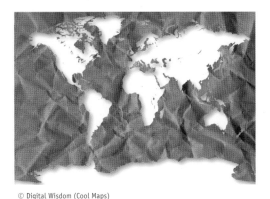

© Digital Wisdom (Cool Maps)

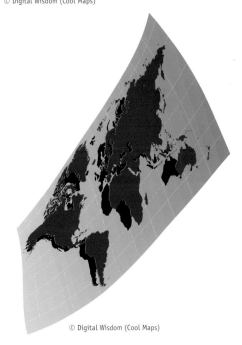

© Digital Wisdom (Cool Maps)

Double Decker Studios
381 Congress Str.
5th Flr
Boston, MA 02210
(617) 357-0337
(617) 542-3765 (fax)
doubledecker@aol.com
http://www.doubledecker.com

© Double Decker/The Learning Company

Double Decker Studios is a new media company providing digital solutions for a wide range of customers with differing needs. The Learning Company was one of the clients with a unique problem. The company needed one thousand vector clip art images for a project but only had two months to create them.

© Double Decker/The Learning Company

The Learning Company selected Double Decker Studios to create a one-of-a-kind collection because of the studio's reputation for strong illustration skills in new media projects. Using two designers who worked ten hours a day, the studio produced all one thousand images on time.

Each image was drawn by hand and then scanned and imported into Adobe Illustrator where it was colorized and then saved as an EPS file. Each file was also transferred into a PC and saved in the WMF format.

© Double Decker/The Learning Company

These images are selections from the custom collection.

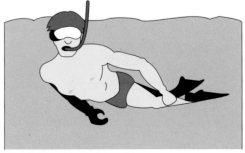

© Double Decker/The Learning Company

DS Design
1157 Executive Circle
Ste. D
Cary, NC 27511
(919) 319-1770
(919) 460-5983 fax
sales@dsdesign.com (e-mail)
http://www.dsdesign.com

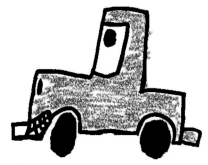

© DS Design

DS Design's collection of clip art created by children is one of the most unique clip art collections you'll find. In fact, it's the only collection of clip art and fonts created by children. The images are original works of art drawn with paint, crayon, watercolor, pastels, and marker pens. The royalty-free collection includes color and black-and-white images.

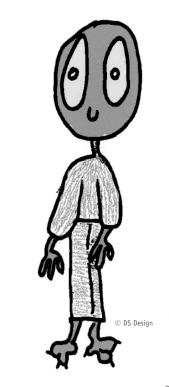

© DS Design

© DS Design

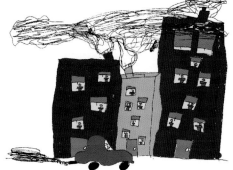

© DS Design

Dubl-Click Software Corporation
20310 Empire Ave.
Ste. A102
Bend, OR 977-5713
(541) 317-0355

Dubl-Click Software creates software as well as some versatile and inexpensive clip art images. The company's ten-volume set of WetPaint clip art is available on one CD-ROM. There are more than seven thousand images on the disk viewable in Aldus Fetch, Multi-Ad Search, and usable in a wide range of software, even clunky old MacPaint. The disk is also readable on PC and Windows machines and supports TIFF and PCX file formats.

The collection also includes two useful utilities: ArtRoundup and PatternMover. ArtRoundup is a feature-rich viewer that also allows you to scale invert, flip, and rotate images. PatternMover allows you to edit and move patterns between paint files.

© Dynamic Graphics (Boldstrokes)

Dynamic Graphics
6000 N. Forest Park Drive
Peoria, IL 61656-3592
(309) 688-8800
(800) 255-8800 (orders)

Dynamic Graphics offers so many different clip art collections that it's hard to start describing them. The company's full-color catalog has more pages than some magazines. All of the clip art is top-quality work.

Some of the collections remind you of the images used in newspaper advertisements. In addition to these collections, Dynamic Graphics has several dozen clip art collections that are definite eye-openers. Many of them are unique, exciting images.

Here is a brief description of four of the company's collections:

Boldstrokes 1

This collection of black-and-white line art contains one hundred EPS images. The strong lines in each image capture your attention immediately, while the exaggerated details add dimension. The images are concept-oriented yet general in nature, so it's easy to find dozens of uses for each one.

© Dynamic Graphics (Boldstrokes)

Quickclips 1

This collection of one hundred color object photography images is part of the company's object photography and clip photography image series. The one hundred images in this collection are Photoshop EPS files in ready-to-print CMYK format. Each includes a clipping path and shadows.

© Dynamic Graphics (Quickclips)

© Dynamic Graphics (Quickclips)

3D Art in Depth

This collection of clip art images really is unlike anything you've ever seen. Each of the forty images in the collection is a piece of 3-D clip art. Each image comes in three file formats: Ray Dream Designer, DXF, and 266 dpi TIFF. A free interactive tutorial is included on the disk to show you how to open and edit the images in Photoshop, Ray Dream Designer, and QuarkXPress.

© Dynamic Graphics (Art in Depth)

© Dynamic Graphics (3D Art in Depth)

Design Elements 4 Color Graphics

Buckle your seatbelt and hang on. It's hard to believe you can get such high-quality color clip art. Each of the 120 images in this collection is a layered EPS file. The collection gives you a whole new dimension of design possibilities, with images related to home, office, entertainment, travel, international, and seasonal themes.

© Dynamic Graphics (Design Elements 4 Color Graphics)

© Dynamic Graphics (Design Elements 4 Color Graphics)

Educorp
7434 Trade Str.
San Diego, CA 92121
(800) 843-9497
(619) 536-2345 fax
http://www.educorp.com

Educorp specializes in giving its customers a lot of clip art for a small amount of money, so if you're looking for lots of images and you're on a tight budget, this is the library to investigate. Collections include Sports-ROM, sports clip art in 300 dpi TIFF format; Kids, images of babies and young children; and Antique Toys, historical images of older toys.

FontHaus
1375 Kings Highway East
Fairfield, CT 06430
(800) 942-9110
(203) 367-1860 fax
fonthaus@aol.com

This company offers a unique and quirky collection of picture fonts, including Art Parts, a thirteen-set library of drawings by two Los Angeles artists. Categories of images include health/medical, patterns, and business.

Handcraftedfonts Co.
P.O. Box 14013
Philadelphia, PA 19122
(215) 922-5584
(215) 922-0779 (fax)
jonathan45@aol.com

The Frakenfont collection of picture fonts is totally customizable. As its name implies, it is a collection of anatomical images you can use to create your own pictograph of a human figure.

Highlander Graphics Software
960 Robbie Way
Windsor, CA 95492
(888) 999-2358
(415) 883-5332 (fax)
http://www.underbridge.com/
market/highland/

Ready for something different? How about Celtic clip art? Highlander Graphics Software creates painstaking illustrations in the ancient and contemporary art styles of the Celts. All of the images are filled with hand-drawn imagery rendered by the company's own artist and illustrator.

There are several different collections of art to choose from, including the Celtic Collection Volumes One and Two, the Celtic Wedding Collection, and Celtic Holidays.

© Highlander Graphics

© Highlander Graphics

© Highlander Graphics

© Highlander Graphics

Image Club
c/o Publisher's Mail Service
10545 West Donges Court
Milwaukee, WI 53224-9985
(800) 661-9410
(800) 814-7783 fax
http://www.imageclub.com

These folks have so much clip art and so many clip images, they have their own catalog. Some of the items in the catalog come from companies mentioned in this book, but some are Image Club exclusives. Image Club also offers a good selection of picture and alphabet fonts.

Letraset USA
40 Eisenhower Dr.
Paramus, NJ 07653
(800) 526-9073
(206) 771-5911 (fax)

Letraset makes a number of font collections you have to see to believe, including classy and distinctive picture fonts. The Letraset catalog is a visual feast guaranteed to whet your appetite for fonts.

Little Men Studio, Inc.
17 Highland Avenue
Redding, CT 06896
(203) 544-8708 phone
http://members.aol.com/imen
studio

Little Men Studio designs digital products for print and Internet design. It is a wonderful source for "boutique" clip art. Each piece of clip art looks new and refreshing. Nothing run-of-the-mill.

The company sells Web-ready graphic elements, including buttons, bars, and backgrounds. Its current line-up of clip art collections includes five different selections: Atomic Cafe, Art Bytes, Metal Loids, Tasty Zots, and Clipto Graphics. Each collection has ninety color images and ninety versions in black-and-white. All are EPS files.

© Little Men Studio, Inc.

© Little Men Studio, Inc.

© Little Men Studio, Inc.

© Little Men Studio, Inc.

© Little Men Studio, Inc.

© Little Men Studio, Inc.

© Little Men Studio, Inc.

© Little Men Studio, Inc.

Monotype Typography
150 South Wacker Dr.
Suite 2630
Chicago, IL 60606-4202
(800) 666-6897
(312) 855-9475 (fax)
http://www.monotype.com

If you're looking for inexpensive, conservative picture fonts, you'll find them at Monotype. The company also offers inexpensive niche design software, such as BorderMaker—a utility that creates borders from images—and T-ShirtDesignMaker, which creates T-shirt designs.

New Vision Technologies, Inc.
38 Auriga Drive
Unit 13
Nepean, Ontario
Canada K2E 8A5
(800) 387-0732

This company's collection includes ten thousand vector images and five hundred scanned, bitmapped photographs. An image viewer and basic editing program is including with the images.

One Mile Up
7011 Evergreen Court
Annandale, VA 22003
(703) 642-1177
(703) 642-9088 fax
http://www.onemileup.com

One Mile Up Inc. is the creator, designer, and manufacturer of the Federal Clip Art Libraries, a massive collection of digital clip art created on a computer by professional illustrators for use by desktop publishers competing for U.S. government work.

The Federal Clip Art Libraries comprise fourteen different collections containing more than 7,800 computer illustrations hand-drawn to government specifications. The meticulously created images depict military insignia, combat art, foreign and domestic maps, flags, and coats-of-arms.

Each image is in EPS format and layered. Individual items, such as countries, landing gear, or crests, can be extracted from the images.

© One Mile Up (Federal Clip Art)

© One Mile Up (Federal Clip Art)

RT Graphics
P.O. Box 45300
Rio Rancho, NM 87174
(800) 891-1600
(505) 891-1350 fax

If you're looking for Native American and Southwest clip art, you've come to the right place. These images are inexpensive and highly detailed. The Santa Fe Collection and the Plains Collection are the company's two major collections.

©Tech-M

©Tech-M

Tech-M
9720 Executive Center Drive N #203
St. Petersburg, FL 33702
(800) 576-1881
(813) 577-7207
techm@cent.com
http://www.cent.com/techm

(Discounts offered for purchasing directly from the Internet!)

This company specializes in the nuts and bolts of clip art—literally! Tech-M's various Pop-In Parts clip art collections are detailed, realistic black-and-white line art drawings of objects. All images are created in Adobe Illustrator and are saved as vector graphics: EPS for the Macintosh and EPS, WMF, or CGM for the PC. Tech-M also offers custom illustrating services if you need something you can't find in one of the collections or would like to have a customized set of clip art created.

The Pop-In Parts collections include network symbols, pipe fitting parts, mechanical fasteners, technical publication pack, and hands. Other collections include schematic symbols and computer parts.

Now for something completely different . . . Tech-M also creates and markets a collection of Egyptian glyph clip art. This collection of two hundred images plus alphabet offers a cool way to dress up a design. Use the images as they are or colorize them in an image-editing program. Either way, you'll have designs fit for a king.

©Tech-M

©Tech-M

©Tech-M

TechPool Corporation
1463 Warrensville Center Rd.
Cleveland, OH 44121
(216) 382-1234
(216) 382-1915
http://www.lifeart.com
lifeart@techpool.com
(e-mail)

TechPool Corporation has two divisions, TechPool Studios and TechPool Software. TechPool Studios is responsible for creating and distributing LifeArt, the best and largest collections of medical illustrations in the world. LifeArt images are high-quality, computer-created medical images. Each image is tested and reviewed by a panel of medical experts for realism and accuracy.

Aside from their richly detailed and anatomically correct color line art images of every part of the body, TechPool offers two other collections you should know about. The new 3-D Super Anatomy Collection simply has to be seen to be believed; the images in this collection are photorealistic 3-D human anatomy images. LifeArt Kids is a collection of cartoons of doctors, nurses, moms, kids, and animals. The images add a warm, fuzzy touch to health-care designs.

T/Maker
1390 Villa St.
Mountain View, CA 94041
(800) 986-2537

T/Maker offers an amazing variety of clip art collections. Some are sold only by the company, but the company also sells collections created by specialty clip art companies. Images from T/Maker's ClickArt series are familiar to many designers. Art Parts, a collection of goofball to elegant images reminiscent of woodblock engravings, is part of this series. So is the Click Art Studio Series, which includes hundreds of inexpensive color, black-and-white, and photorealistic bitmap images.

You'll find T/Maker general collections in most large computer retail stores. These collections contain tens of thousands of color and black-and-white clip art images. Look in stores and in the company's catalog for the Famous Magazine Cartoons collections and the Click Art Cartoons collections.

Treacyfaces, Inc.
P.O. Box 26036
West Haven, CT 06516
(203) 389-7037
(203) 389-7039 (fax)
treacyface@aol.com

Typographic clip art is what you get in these ten collections. They are intended for use as drop caps or initials, each font comprises seventy-eight characters (give or take a character or two). You can buy single letters, numbers, or punctuation marks, twenty-six capital letters or the whole font.

Zedcor Inc.
3420 N. Dodge Blvd.
Tucson, AZ 85716
(800) 482-4567
(800) 482-4511 (fax)
http://www.arttoday.com

© Zedcor, Inc.

With more than six hundred thousand pieces in its clip art collection, Zedcor can easily support its claim to having the largest assembly of electronic clip art in the world. The collection includes many of the images found in the Dover Publication's Clip-Art and Pictorial Archives, one of the most well-known and respected clip art collections in the world.

There are two ways to dip into this vast and rich resource: on-line or on CD-ROM. You can search for and view images in the database at this Web site: http://www.arttoday.com. You have to pay a small monthly access fee to download the images. You can also purchase a CD-ROM collection of some other images. The fifteen CD-ROM collection is called Desk-Gallery and contains more than one hundred thousand images in various raster file formats. Each disk works on either a Macintosh or PC.

© Zedcor, Inc.

All of the images in DeskGallery collection are black-and-white only, although they are very easy to colorize. All were scanned at 600 dip and saved in compressed format on the disks.

© Zedcor, Inc.

GLOSSARY

alphabet font: set of characters comprised of letters from an alphabet: Western, Cyrillic, Kanji, etc., and is installed as a font on a computer.

ASCII: acronym for American Standard Code for Information Interchange, also a form used to store text-only files, containing no formatting information other than tabs and carriage returns.

auto trace: procedure available in image-editing software and other software for turning bitmap images into vector images.

bitmap: graphic file where pixels are used to create an image; image scans are usually saved as bitmap graphics.

border: type of clip art generally used as a decorative element; sometimes used as frames or a divider between text or other graphic elements.

browser: *see* viewer.

cartoons: a type of clip art or graphic illustration, usually intended to be humorous.

CD-ROM jukebox: external omputer hardware device accommodating many CD-ROMs simultaneously; discs can be stored in jukeboxes and accessed as needed.

CD-ROM recorder: computer hardware used to burn or record computer files onto a blank CD-ROM.

clip art: prefabricated images—on paper or saved as digital files—created to be imported and used as graphic design elements.

CMYK: acronym for Cyan, Magenta, Yellow, and Black, the four colors used in process printing. *See* process colors and spot colors.

colorize: to add color to a black-and-white clip art image, usually in an image-editing program.

copyright: legal rights held by the creator of an original work—including the right to copy and display the work.

dingbat: A decorative graphic used to separate text or other design elements; often used in lists or at the end of a section of running text.

dpi: acronym for dots per inch, related to resolution.

draw program: software in which digital drawings are created and edited.

drop shadow: often used with object photography; a digitally created shadow that appears slightly behind and to the left or right of the object.

dual platform: software that can run on two kinds of computers, usually a Windows-based PC, and a Macintosh.

embed: to put one file inside another; in the context of clip art, it usually means an EPS file is included inside another EPS or other graphic file. Also referred to as "nest."

EPS: acronym for Encapsulated PostScript, a versatile vector file format often used for complex images.

file compression: a means of shrinking a file.

file format: a standardized method for arranging digital data. EPS, TIFF, and PICT and examples of file formats.

filter: software inside a software program that converts a file into a format the software program can understand.

freeware: computer software distributed free of charge by its creator.

graphic conversion programs: computer software that converts one graphic file format into one or more others.

grayscale: graphic image comprising varying shades of gray.

group: linking several objects together—typically in an image-editing program—so that they function as one object.

icon: a symbol or graphic image used to represent something abstract or an action; also called "pictograph."

image database: software that can store and organize graphics with text description.

image-editing program: computer software for altering and manipulating graphic images.

import: action taken in a software program to bring a file into the document or image currently being worked on.

line art: graphic image comprising lines, either black only or colored.

layer: a section of a graphic image that exists on one level or plane. Multilayered images, also known as layered images, are more versatile because you can make changes to one or more layers.

layout: term used to describe how elements are arranged in a design, i.e., page layout describes how elements are arranged on a page.

letter graphic: clip art of alphabet characters comprised of individual files and not installed as a font on a computer.

map: a type of clip art, often showing a geographical representation of territories as large as countries and continents or as small as an office or backyard.

native-format: file format created by a particular application.

object-oriented: *see* vector.

object photography: type of clip art that originates as photographs; usually a picture of a single item shown without a background.

paint program: software in which paintings can be created; typically used to change the colors of or add colors to clip art.

path: line drawn between two points.

PDL: acronym for Page Description Language, a set of rules describing the content of a page for display on-screen or for printing. PostScript is a page description language.

photorealistic: an illustration that looks like a photograph.

pictograph: *see* icon.

picture font: set of characters—installed as a font on a computer—in which each character is a picture or dingbat.

PICT: file format used for Macintosh image-editing programs.

pixel: truncation of "picture element," usually a dot, the smallest discrete element of a graphic image.

PostScript error handler: software that, when downloaded to a PostScript printer, will print out any PostScript errors encountered.

PostScript: page description language created by Adobe. PostScript Level One was created for use with the first Apple LaserWriter; Level Two included more complex formatting commands for color imaging; PostScript Three includes multiple language support.

preflight utility: software that checks print files for errors and other problems that may hinder output.

process colors: hues created by combining varying amounts of cyan, yellow, magenta, and black. For example: cyan and magenta in different combinations make different shades of blue.

raster: *see* bitmap.

removable media: storage disk or other media that can be removed from the computer or external drive hardware. Floppy diskettes and magneto-optical cartridges are examples of removable media.

resize: change the size of a graphic.

resolution: number of dots in an image or the number of dots to be used when the image or document is printed, often expressed as dots-per-inch, or dpi.

RGB: acronym for Red, Green, Blue, a color model using these three colors to create other colors.

rotate: to change the horizontal and/or vertical orientation of a graphic.

royalty-free: usage rights for an image that requires no further fee to the owner of the image's copyright beyond original purchase price if the rules set by the copyright holder are followed.

shareware: a full working version of software that can be tried before purchase, often found on bulletin boards or on the Internet. If you keep using the software, you are expected to send a small fee to the software's creator.

silhouette: outline or a solid black object used to represent an object.

spot color: a color created by a single premixed ink.

symbol: type of graphic image that represents an abstract concept.

text box: space in a page-layout or image-editing program into which you can type or import text.

third-party: "helper" software used with an application, created by another person or company. MetaCreations Kai's Power Tools for Adobe Photoshop plug-ins are an example.

TIFF: acronym for Tagged Image File Format, a type of bitmap graphic often used for scanned images.

trap: to slightly expand one adjacent color into another to prevent gaps or color shifts in the image when printed.

usage rights: rights to use an image; not to be confused with copyright or ownership—you can obtain permission to use an image without obtaining the copyright.

vector: mathematically defined curves and line segments. Vector graphics (also known as object-oriented graphics) are infinitely scalable and can be printed at any resolution without appearing jagged or distorted.

viewer: software that provides an onscreen rendition of a graphic image without having to import it into an application or file.

INDEX

CREDITS

Page	Company
1	(chef) T/Maker
3	(X-Acto knife) T/Maker
7	(quill pen) T/Maker
8	(hinge) Dynamic Graphics; (globe) DS Design; (Santa, mouse) T/Maker; (telephone) Classic PIO Partners
9	(flower) Highland Graphics; (map) Cartesia; (clock) Dynamic Graphics
10	(bear) Zedcor
11	(pointer, elements from quilt square) T/Maker; (FYI graphic) Dynamic Graphics
12	(cowgirl, manufacturing graphic) T/Maker
13	(adding machine) Classic PIO Partners; (man) Dynamic Graphics
14	(building) DS Design; (disk) T/Maker
15	(computer) DS Design; (chef) T/Maker
16	(rabbit, woman) T/Maker
17	(X-Acto knife) T/Maker
18	(head and woman) T/Maker
19	(computer) T/Maker; (map) Cartesia
20	(shoes) T/Maker
21	illustration created with elements from T/Maker
22	(clamp) Dynamic Graphics; (cowboy) T/Maker; (map) Digital Wisdom
23	(woman, bulletin board) T/Maker
24	(all) T/Maker
25	(building) T/Maker; (wooden model) Dynamic Graphics; (building) T/Maker
26	brochure cover created with elements from Little Men Studio
27	(top image, bird) Highland Graphics; (blender, toaster) Classic PIO Partners; (knife, spoons) Dynamic Graphics
29	(apple, cherries) T/Maker
30	(all) T/Maker
31	Web page created with elements from Little Men Studio
32	T/Maker
33	T/Maker
34	T/Maker
35	(clock) T/Maker; (elf, pocket watch) Dynamic Graphics
36	(all) Dynamic Graphics
37	(burst, anvil, accordion, church, rabbit) T/Maker; (swirl) Highland Graphics
38	(all) T/Maker
39	(all) Dynamic Graphics
40	(cat/dog stamp) Dynamic Graphics; (father time) T/Maker
41	(books) Dynamic Graphics; (woman, bulletin board) T/Maker
42	Dynamic Graphics
43	advertisement created with elements from Dynamic Graphics
44	Dynamic Graphics images
45	(all) Dynamic Graphics images except for "stacked-televisions" illustration created with elements from T/Maker
46	(sun, Eiffel tower) Dynamic Graphics; (stars) T/Maker
47	(all) Dynamic Graphics
48	(clipboard) Dynamic Graphics; ("D," moon) T/Maker
49	(all) T/Maker
50	(all) Dynamic Graphics except stars from T/Maker
51	(all) T/Maker
52	(map) Cartesia; (orange) T/Maker
53	(all) DS Design except "stacked-televisions" illustration created with elements from T/Maker
54	(all) T/Maker
55	(all) T/Maker
56	(all) T/Maker
57	(all) DS Design
58	(all) T/Maker
59	(all) T/Maker
60	(all) T/Maker
61	quilt square created with elements from T/Maker
63	(shoes, chef) T/Maker
64	(dice and lips) T/Maker
65	(porcupine, skull) T/Maker
66	(stethoscope) Dynamic Graphics
67	(smiley faces) created in QuarkXpress
68	(trash can) T/Maker; disk illustration created with elements from T/Maker
69	(all) T/Maker
70	(camera, adding machine) Dynamic Graphics; (wooden model, shoes) Classic PIO Partners
71	(golf clubs) Dynamic Graphics; (map, globe, man at desk) Digital Wisdom
72	(computer) T/Maker; (CD) Little Men Studios
73	(all) Dynamic Graphics
74	(radio) Classic PIO Partners; (safe, X-Acto knife) T/Maker
76	(radios, microphone, toaster, hula girl) Classic PIO Partners; (globe) Digital Wisdom
77	T/Maker
78	Classic PIO Partners, camera
79	book cover created with camers from Classic PIO Partners
80	(picture font characters) DS Design; (letter graphics) T/Maker
81	(frame at top left, bird) T/Maker; (frame with stars and swirls) Dynamic Graphics; (Celtic frame) Highland Graphics; (abstract border) ????
82	(celtic icon, borders) Highland Graphics; T/Maker, chef
83	(frame and Hawaiian sunset) Dynamic Graphics
84	(Celtic border) Highland Graphics; (borders) created with a Dynamic Graphics illustration
85	framed skysacraper illustration created with elements from T/Maker and Highland Graphics
86	(fall border) Dynamic Graphics; (father time, quill pen) T/Maker
87	(all) T/Maker
88	(all) Highland Graphics
89	(all) Highland Graphics
90	(all) Dynamic Graphics
91	T/Maker
92	(shoes, flower, buttons) T/Maker; (plugs, hand, Egyptian) Tech-M
93	(man with globe) T/Maker; (flat, square maps) Digital Wisdom; (round map) Cartesia
94	(people at desk) T/Maker; (woman at desk) Dynamic Graphics
95	(man) T/Maker
101	(all) T/Maker
102	(elf) Dynamic Graphics; (pen) T/Maker
103	(all) T/Maker
104	(gavel) T/Maker; (book) Little Men Studio
105	(Statue of Liberty) Dynamic Graphics
106	(all) T/Maker
107	(all) Dynamic Graphics
108	(all) T/Maker
109	(all) Dynamic Graphics
110	(all) Dynamic Graphics
111	(all) T/Maker
112	(people with computer) T/Maker; (counting sheep) Dynamic Graphics
113	(clipboard) Dynamic Graphics; (bookworm) T/Maker
114	(all) T/Maker
115	(butterflies, bee) T/Maker; (keyboard illustration) Dynamic Graphics
116	(all) T/Maker
117	(all) T/Maker
118	(all) T/Maker
119	(all) T/Maker

Screen shots provided by the author; all borders and Quick Tip brackets created from T/Maker clip art.

FEATURED DESIGNERS

Kim Victoria, who designed the letterhead project on page 89, has spent her lifetime learning artistic techniques in a wide variety of media. She has had extensive instruction in Old Masters techniques. Kim has always loved to draw and her husband, Tom Watson, a computer expert and graphics designer for the past fifteen years, saw the potential of putting her expertise to work. Together they created their company, Highlander Graphics Software, which specializes in Celtic art and design products and produces clip-art images.

Mike Stone, who designed the object photography project on p. 79, works at Belyea Alliance, a Seattle design firm.

CopperLeaf Visual Communications, which designed the cover and page layouts of *Clip Art Smart*, collaborated with the author to help customize some of the clip art illustrations in the book. CopperLeaf has worked on more than four hundred books and produces high-end images from its studio in Columbus, Ohio.

Daniel Donnelly, who designed and produced the *Clip Art Smart* CD-ROM, owns InterActivist Designs, a multimedia studio located in Chico, California. His firm specializes in Web design, CD-ROM production and development, and interactive presentations for corporate clients. Donnelly teaches multimedia design at the collegiate level, and has written four books for Rockport, including *In Your Face: The Best of Interactive Interface Design*, *WWW Design From Around the World*, *Upload*, and *Cutting Edge Web Design*.

ACKNOWLEDGMENTS

My thanks to the entire staff of Rockport Publishers for believing in the concept of *Clip Art Smart* and helping to bring it to fruition. I also thank them for their continued confidence in me and for being such nice folks to work with.

My thanks to the staff of Seybold Publications, especially to the editorial management of the company, for taking a computer person under their wings and patiently explaining the intricate workings of the desktop publishing industry.

My thanks to all the companies and graphic artists for their participation, art work, graphics and encouragement during the course of this project. It would not have been possible to create the book without them.

Finally, my eternal thanks to Ms. Cochran, the woman who lived across the street from me when I was five years old, for handing me a pencil and a pad of paper and encouraging me to write.

Molly W. Joss